Christmas in BIRMINGHAM

Tim Hollis

THE
History
PRESS

Published by The History Press
Charleston, SC
www.historypress.net

Unless otherwise indicated, all images are from the author's collection.

First published 2015

Manufactured in the United States

ISBN 978.1.62619.702.2

Library of Congress Control Number: 2015948349

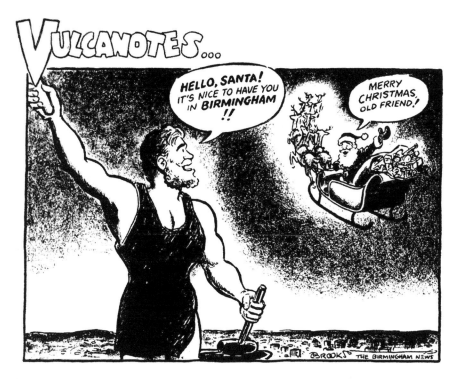

Charles Brooks's editorial cartoons for the *Birmingham News* were always delightful, but his *Vulcanotes* subseries, in which he commented on various happenings in the city, were a special treat. This example of one of his Christmas Eve installments seems an especially appropriate way to start off this journey through the many aspects of Christmas in Birmingham.

CONTENTS

CITY SIDEWALKS, BUSY SIDEWALKS

For each person who lived in Birmingham or in the suburban area stretching for miles in all directions, there was a particularly fond memory of the Christmas season. In the pages that follow, we will be revisiting many of those memories created by the malls and shopping centers, radio and television programs and churches and hospitals. But it cannot be denied that when most people of a certain age—maybe past forty—think of Christmas in Birmingham, it is the downtown retail district that most immediately comes to mind. And it follows that the two stores that loom largest in those memories are those behemoth mercantile establishments Loveman's and Pizitz.

Fortunately for the limited space we have in this book, the stories of how these two titans cornered the Christmas market in Birmingham have already been related in two other titles: *Pizitz: Your Store* (2010) and *Loveman's: Meet Me Under the Clock* (2012). Therefore, here we will try to hit on some topics that were not included in those volumes and simply summarize a few others.

Loveman's, known formally as Loveman, Joseph & Loeb until the 1920s, had been in Birmingham since 1880, with Louis Pizitz opening his rival store in 1899. Actually, in the beginning, Pizitz was not considered much of a rival to the grander, longer-established Loveman's, but within fifteen or twenty years, the two were practically carbon copies of each other.

We can get a fascinating picture of Christmas at the beginning of the twentieth century from a newspaper ad Loveman, Joseph & Loeb ran on December 1, 1900. In those days, ads consisted of more words than graphics,

By the time of this Christmas 1913 ad, Loveman, Joseph & Loeb had been in business in Birmingham for almost thirty years and had obviously established itself as the city's first choice for holiday shopping.

reading much like the news articles that surrounded them. Thus, Loveman's editorial began like this:

> *Retrospect for a minute. Remember it has been customary in Birmingham during past years to do the Christmas shopping after the 15th of December? Indeed, buyers crowd most of the shopping into the week prior to Christmas. This is wrong. The way it ought to be and why, we here tell.*
>
> *We ask as a special favor that you help us carry out this idea: Begin your shopping Monday, December 3. It is to your advantage to do so.*

The idea of waiting until December 3, much less the fifteenth, to begin one's Christmas shopping may seem like it belongs not just in another century but on another planet considering that most stores today have decorations appearing in mid-September. It is just as surprising to learn from those ads of 1900 that stores did *not* close on Christmas Day; Loveman's was open

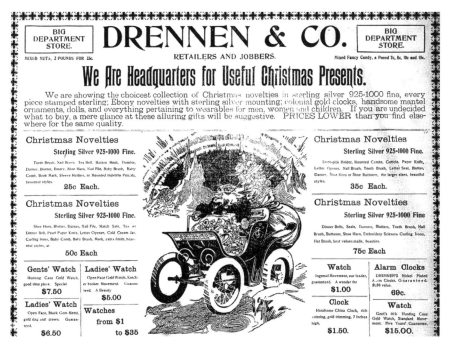

The Drennen department store was one of those early businesses that did not survive into the period most living people remember. It is interesting, though, to note that this ad from 1900 depicted Santa Claus in an early automobile; the Drennens eventually left the store business to open an automotive dealership that lasted for a century.

until 1:00 p.m. on the holiday, and nearby Drennen & Co. kept open from 8:00 a.m. until midnight on Christmas Day. But over the next several years, other changes would take place that illustrated the evolving cheerful visage of Christmas downtown.

Most historians agree that while a few department stores in large cities began having their own Santa Claus on the premises in the late 1800s, it was not until the 1920s that the custom became widespread. Thus, it is

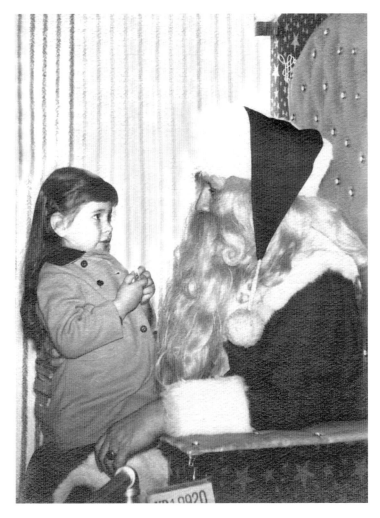

There is something priceless about the expression on young Carolyn Ritchey's face as she encounters Loveman's Santa Claus in the early 1950s. It just may be longtime Loveman's Santa Dave Campbell under that beard and wig. *Carolyn Ritchey collection.*

fitting that a Loveman's ad from November 21, 1920, seemed to feature a certain novelty aspect:

> *It is being whispered among the younger set that there is a real live Santa Claus after all. And they are as right as can be. The dear old fellow is here to prove it with his bright red suit and his long white beard. He comes every afternoon at two and remains until five. Three joyous hours for the kiddies. Then he hastens back to his workshop to catch up on back orders for toys for good little boys and girls.*

So, jolly old St. Nick was taking time out from his busy schedule to hang out in Loveman's fourth-floor toy department each day, huh? But wait—what was this? A week later, the newspaper began featuring daily missives from the bearded one that said nothing about him being at Loveman's. Instead, these epistles stated that Santa would arrive on the Louisville & Nashville (L&N) train on Saturday afternoon, December 4, and he wanted all the kids to be there to meet him. Huh?

Then, the day before Mr. Claus's expected arrival, he sent another letter to be printed—and this one made the whole situation as crystal clear as an Arctic icicle:

> *I will arrive Saturday afternoon at 4 o'clock on L&N fast train. Meet me at the station. I am bringing some little things that I am going to give away as long as they last when I arrive.*
>
> *I have accepted Louis Pizitz's offer of his store for my headquarters during my stay in Birmingham. I accepted his offer because of the splendid proposition made me. But, greatest of all, because Mr. Pizitz thought so much of the Birmingham children, he traveled more than 3,000 miles this past summer to see me and my wonderful toy shops in England, France, Switzerland, etc., where he bought great lots of toys for me. Then Mr. Pizitz offered me the entire freedom of his big store in which to display my gift things and to meet all my children friends. He told me I could have them all here to meet me, and I want you to come to the Pizitz store and shake hands with me and tell me what you want me to bring you.*

And so began the annual battle of the store Santa Clauses, which would not end until Loveman's went out of business forever in 1980. And what Pizitz and Loveman's started, the other stores gradually picked up, with the result that, by the 1940s, there was a Santa on duty at most of them.

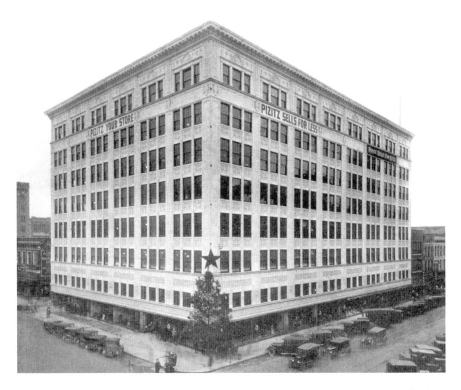

Not to be outdone by its older rival, the Pizitz store moved into an imposing new edifice in time for Christmas 1925. Notice the tree set up on the corner to celebrate the season.

This did not sit well with some parents, and in 1947, a group of them tried to champion a "One Santa Claus" idea through the *Birmingham News*. They insisted that seeing a Santa in each and every toy department was confusing their youngsters; trying to convince them that the red-suited horde was Santa's helpers instead of the genuine article was hard to do when stores (namely, Pizitz) sponsored radio programs that got across the idea that their Claus was the one and only. One mother of unspecified age, but who no doubt grew up in the years prior to 1920, spoke for her generation: "Personally, I'd like to go back to the idea that Santa is seldom seen. We rarely saw him when I was a child. Many anxious Christmas Eves I've scanned the sky for signs of the reindeer. The imaginary personage was much grander than the sorry figures now seen."

What was the suggested solution? That during the season, Santa set up his headquarters at one specified site, with all the different stores pitching in to sponsor their own events in conjunction with it. Well, obviously that never happened, although it is interesting to see that eventually the rise of the shopping centers and malls did produce somewhat the same effect, with each

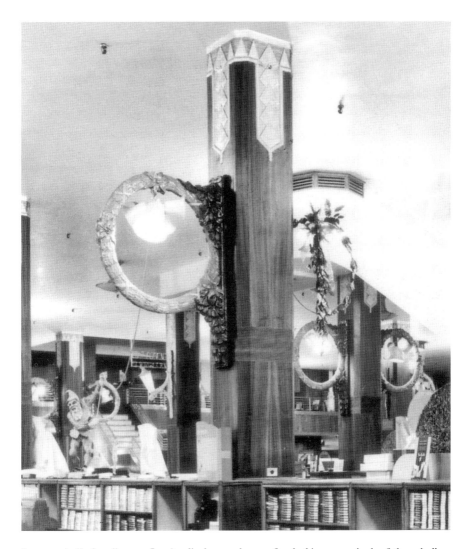

Loveman's display director, Joe Apolinsky, was known for decking every inch of those halls when it came time for Christmas. This close-up view gives a hint of the many layers of detail his decorating entailed. *Harold Apolinsky collection.*

one having a single Santa rather than multiples in all of their stores. That still did not help kids who visited Santa at Eastwood Mall in the morning and Century Plaza in the afternoon—they couldn't understand why he did not seem to remember talking to them or what they wanted for Christmas. How was such an absent-minded old geezer supposed to keep up with their requests all the way until Christmas Day?

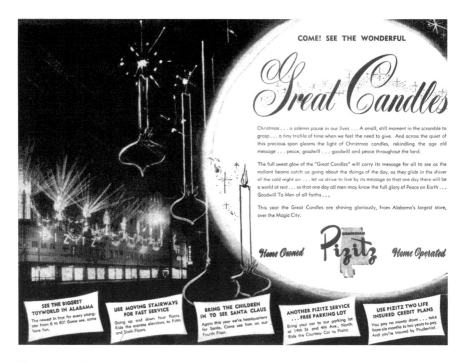

Photographs showing any department store display windows, or even the exterior decorations, are almost nonexistent. We must content ourselves with advertisements, such as this one from 1954 promoting Pizitz's "Great Candles" theme for that year.

Besides their battling Santas, Pizitz and Loveman's had other ways of competing, and those included their lavishly decorated show windows. Ask those who shopped downtown in the 1940s and 1950s, and they will wax poetic about the joy those windows, with their animated animals and other mechanical figures, brought each year. For all of that, though, there seem to be no surviving photographs of any of them. There are photographs of the store windows displaying various types of merchandise for Christmas gifts but none showing the beloved animated scenes that live on in memory after memory.

In 1964, Pizitz's sales promotion department hit upon an idea that would prove to be its ultimate ammunition in the annual yuletide war. Some smart elf had the brilliant idea that if window displays could draw immense crowds to the sidewalks outside the store, a similar feature inside the store could be more than worth its cost in the numbers of shoppers who would be passing through the doors. And, he or she reasoned, putting such a display on the sixth floor would ensure that customers had to pass through the lower five levels before getting to it! And so was born the

These renderings of some of the Enchanted Forest's original scenes were used on the covers of a 1965 Pizitz catalogue, the second year the walkthrough display appeared on the store's sixth floor.

Enchanted Forest, the story of which occupies an entire chapter in the aforementioned *Pizitz: Your Store* book.

The initial approach was quite simple. Display director Joe Dultz purchased a set of secondhand animated scenes meant to depict a village of

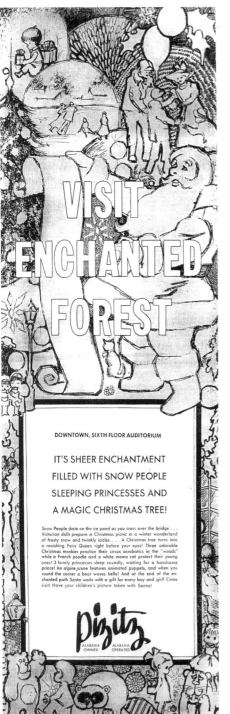

DOWNTOWN, SIXTH FLOOR AUDITORIUM

IT'S SHEER ENCHANTMENT
FILLED WITH SNOW PEOPLE
SLEEPING PRINCESSES AND
A MAGIC CHRISTMAS TREE!

Snow People skate on the ice pond as you cross over the bridge . . .
Victorian dolls prepare a Christmas picnic in a winter wonderland
of frosty snow and twinkly icicles . . . A Christmas tree turns into
a ravishing Fairy Queen right before your eyes! Three adorable
Christmas monkies practice their circus acrobatics in the "woods"
while a French poodle and a white mama cat protect their young
ones! 3 lovely princesses sleep soundly, waiting for a handsome
prince! An alpine scene features animated puppets, and when you
round the corner a bear waves hello! And at the end of the en-
chanted path Santa waits with a gift for every boy and girl! Come
visit! Have your children's picture taken with Santa!

Pizitz

ALABAMA ALABAMA
OWNED OPERATED

bears. These figures were placed in a small, walled-off area of Pizitz's sixth floor amid a setting of snow, frosty trees and twinkling lights, with a "path" meandering throughout the scene.

In 1968, the Enchanted Forest became the home to Santa Claus and his whole holiday crew. With a new store auditorium having recently been completed, the Forest moved into that space instead of its tiny temporary quarters. Late in 1968, Dultz retired and was replaced by Jim Luker, who would take the Forest to heart and make it his own creation for the remainder of its run. Another brilliant brainstorm thundered through the store at about the same time. Until then, the toy department was located on the second floor. One of Santa's more sales-oriented helpers decided it would be better to have the toys on the same floor as the Enchanted Forest, so the playthings paraded up to the sixth floor from then onward. (That's called smart merchandising!)

Jim Luker went about his yearly task with pleasure and with pride,

Most years, Pizitz promoted the Enchanted Forest with elaborate newspaper ads, but this one from 1970 did an especially thorough job of describing the sights visitors would see along the snowy trail.

16

Santa Claus and all of his assorted helpers could be found at work and play in the Enchanted Forest. The display last occupied the sixth-floor auditorium in 1981 and was maintained in Pizitz's corner window until the store was sold to McRae's at the end of 1986.

inventing as he went along. In 1971, he designed a "Talking Christmas Tree" with two-way mirrors for eyes, so the person inhabiting the figure could see the children, but anyone looking at the Tree from the front would be unable to see the operator. The mouth was manipulated by a foot pedal, and Luker was diligent in training Pizitz's female employees to synchronize their speech with the movements of the Tree's lips.

As downtown's fortunes declined, so did those of the Enchanted Forest. It barely survived into the 1980s, last inhabiting the store auditorium in 1981. From 1982 until the sale of the Pizitz chain to McRae's in 1986, the Forest was maintained in name only, returning to its roots as a display in Pizitz's corner window.

Mister Bingle was a snowman character owned by Loveman's parent company, City Stores, and originated at the Maison Blanche department store in New Orleans. Bingle took center stage in this ad from Christmas Eve 1950, the same year he was starring in a daily fifteen-minute TV program on Channel 13.

Of course, what would the holiday season have been without the toy departments? So prevalent were toys during the festive time of year that even stores that did not normally stock playthings would have at least a token toy section. We have already seen how Pizitz wisely tied the toy department to the Enchanted Forest, but Loveman's was no slouch either when it came to dragging in the kiddies.

For years, Loveman's main contribution to Christmas memories was its "Breakfast with Santa" campaign. On weekday mornings, kids could arrive at the restaurant on the mezzanine to share a meal with the jolly old gift-giver who looked like he didn't miss many meals the rest of the year. TV

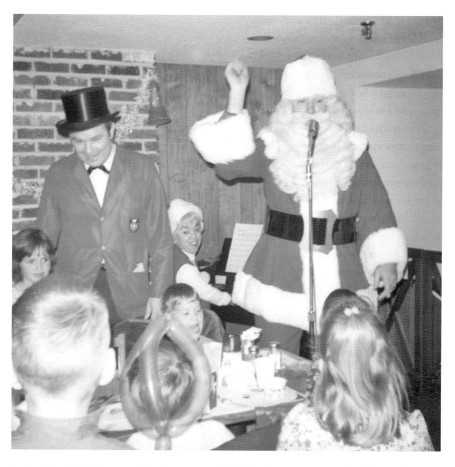

By the late 1960s, Loveman's had its own daily feeding frenzy known as Breakfast with Santa. Mr. Claus appeared in the persona of radio personality Dave Campbell, ably assisted by Cousin Cliff Holman and Loveman's own four-foot-three Del Chambordon as Twinkles the Elf. *Del Chambordon collection.*

legend Cousin Cliff Holman was on hand to perform his magic tricks and tell jokes, but Santa's main helper was Twinkles the elf, played yearly by four-foot-three Adele (Del) Chambordon of the bookkeeping department. Del would daily make her grand entrance down the stairs, belting out "Santa Claus Is Comin' to Town" on her accordion.

The kids never realized that underneath St. Nick's white beard and red suit was another Birmingham broadcasting legend, radio and TV personality Dave Campbell. Playing Santa became a second career for Campbell, who also essayed the role on daily shows from WAPI-TV. Campbell had begun his work with Loveman's in 1952 as the store Santa, listening to one kid's list after another. He told a reporter in 1984, "You have to be a very good kindergarten teacher. You suddenly realize that Santa is a very improbable image for most children. They're suddenly confronted with a white beard, a bright red suit, and a deep voice, and it scares them to death."

Campbell studiously abided by the rules all good Santas follow, such as not promising anything to any youngster. The one time he broke tradition was when a child belonging to one of his friends came to see him and, within dear old Dad's earshot, went over a long list of toys that would tax even the elves' ingenuity. Campbell couldn't resist promising the kid everything on the list. "I stuck him for about $800 that year," said Campbell in retrospect.

By the late 1960s, Campbell was no longer the sit-down St. Nick and was confining his Santa activities to television and the Breakfast with Santa ritual. After Loveman's demise, the Breakfast with Santa club was taken over by Rich's at the Century Plaza mall, where Campbell and Cousin Cliff kept it going for many more years.

Since Loveman's and Pizitz were the two huge one-stop-shopping destinations, the other downtown stores had to carve out their own niche markets. Their complete histories can be found in the book *Memories of Downtown Birmingham: Where All the Lights Were Bright* (2014), so we can give a short rundown of them here.

Some, such as the beloved Parisian, began as full-line department stores and gradually evolved into selling clothing almost exclusively. Others falling into that category included Burger-Phillips and Yeilding's, although in their earlier days they promoted their own store Santas and toy departments just as heatedly as the others. Blach's was a more dignified upper-class store, with proportionately higher-priced merchandise. As far back as 1900, Blach's was selling men's suits for twenty dollars each, a quite astronomical sum for that era.

On the opposite end of the economic scale from Blach's were the "five and ten" stores, also referred to as "variety stores" after they were no longer

Memorabilia and collectibles from Birmingham's Christmas past are not always easy to find, but they occasionally turn up in antique stores.

nickel and diming their customers. F.W. Woolworth, of course, had been the pioneer in this form of mass merchandising, and that establishment moved from building to building downtown before finally settling at the corner of Third Avenue North and Nineteenth Street. The Woolworth success story inspired other variety store chains, all of which seemed to copy not only the line of merchandise but also the format of signage using the founder's two

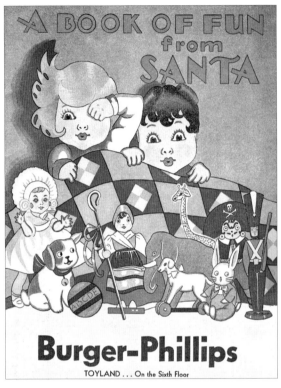

Left: During the Christmas season, even stores that did not usually feature toys in a big way would install a temporary toy department. This coloring book was given away by veteran store Burger-Phillips in 1934.

Below: Entering the downtown Sears store during the Christmas season was like walking around inside the chain's annual Wish Book. The identity of these two employees is unknown, but one can spend a lot of time just exploring the detail in their holiday Sears surroundings. *Polly Chambers collection.*

initials and last name: J.J. Newberry, S.H. Kress and W.T. Grant, to name a few. All had downtown Birmingham presences that were highly anticipated by those who did not have the money to shop at Loveman's or the social standing to walk through Blach's doors.

Way out on the western edge of downtown, the Sears store was another favorite holiday destination. Since the retail giant's annual "Christmas Wish

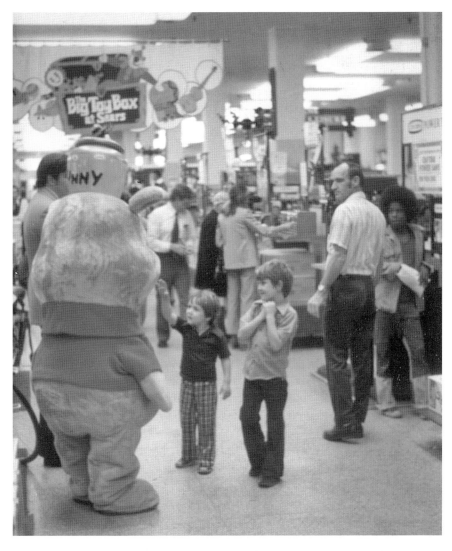

That loveable bear Winnie-the-Pooh made semiannual visits to the downtown Sears store during the 1970s. Hanging from the ceiling, notice Sears' signage for the toy department, tagged as "The Big Toy Box at Sears." *Polly Chambers collection.*

Book" catalogue was such an anticipated harbinger of the season, entering the store was something akin to walking around inside that catalogue full of treats. Sears entertained Christmas shoppers in that building from 1941 until 1989 (it closed in the summer of 1990), but those who were kids in the late 1960s and 1970s have perhaps the fondest memories of it. Who of that age group does not remember the annual promotion, beginning in early fall, built around the theme of the "Big Toy Box at Sears"? In signage and the catalogue, Sears established its name as the source for the largest variety of toys imaginable—and it was hardly wrong.

Beginning in 1965, many of those toys bore the image of lovable Winnie-the-Pooh and his fellow stuffed animals from A.A. Milne's stories and the Walt Disney animated films based on them. Eventually, Sears began sponsoring telecasts of these cartoon classics on NBC-TV approximately twice each year. *Winnie-the-Pooh and the Honey Tree* generally aired in the spring, around the time parents were thinking about shopping for Easter clothes, while *Winnie-the-Pooh and the Blustery Day* could usually be seen during Thanksgiving week. Around the time of each telecast, the costumed Pooh from Disneyland (and later Walt Disney World) made visits to Sears to greet his many fans.

Compared to the department stores, the downtown movie theaters generally took a more subdued approach to Christmas. Most of them—other than the biggest and merriest, the Alabama Theatre—did not do anything in particular to observe the season. Even the Alabama's holiday celebrations were far from consistent, but if something were going to be done, as a rule it was the Alabama that did it.

As early as the 1940s, the Alabama annually promoted the sale of the National Tuberculosis Association's Christmas Seals by holding "Health and Happiness Parties," the admission for which was a front-left-corner seal. For those with a greedier inclination, a 1962 stunt involved an enormous stocking filled with Christmas ornaments that was mounted atop the Alabama's flashing marquee. The citizen who most closely estimated the number of ornaments in the stocking would win a not-so-paltry cash prize of $1,000, with separate $100 prizes going to the next five runners-up. Nothing like a little cold, hard cash to get one in the Christmas mood!

Since one could not always count on a new movie with a Christmas theme being in current release each season, theaters wishing to book appropriate holiday fare usually had to make do by cobbling together a program from previously released flicks. Even when a Christmas movie did make it to the box office, there was no guarantee that it would be tied to the correct season.

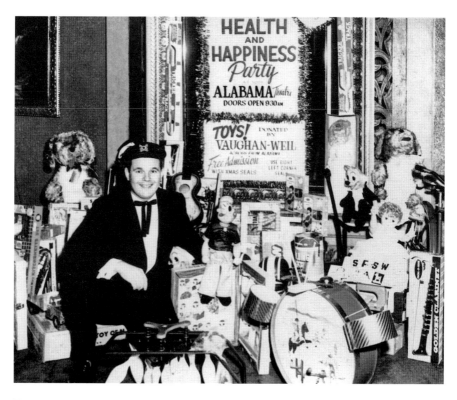

For many years, the Alabama Theatre hosted Christmastime "Health and Happiness Parties" to promote the sale of Christmas Seals or other worthy causes. Here, in 1962, TV superstar Cousin Cliff Holman poses with a stash of donated toys in the Alabama's lobby. *Cliff Holman collection.*

In chapter three, we are going to see how one of the most beloved Christmas movies of all time was actually released in June. When MGM's classic *Meet Me in St. Louis* was the newest thing, it was seen in Birmingham in April 1945. Those who wanted to hear Judy Garland sing "Have Yourself a Merry Little Christmas" (with lyrics by Birmingham native Hugh Martin) had to do so closer to the Easter season. Fortunately, the Bing Crosby/Danny Kaye vehicle *White Christmas* did indeed open at the Alabama during Christmas week 1955, although that meant that people had to wait almost until the season was over before they could see it.

Not everything downtown involved the stores and theaters, nor was it all meant for commercial purposes. In 1973, the North Alabama Chapter of the National Cystic Fibrosis Research Foundation first put on an extravaganza known as "Santa's Station." The name was chosen because this holiday attraction occupied the second floor of the mostly

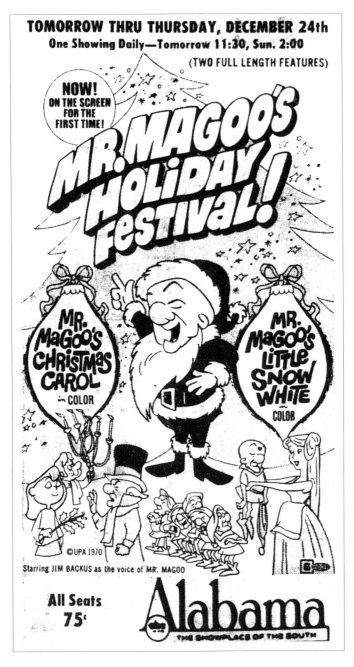

Sometimes movie houses would stitch together a Christmas program from various sources. These cartoons starring that nearsighted bumbler Mr. Magoo were originally produced for television, but in 1970, they ran on the Alabama Theatre's enormous screen for the holidays.

unused L&N Railroad station on Morris Avenue. Other than its location, Santa's Station very much appeared to be inspired by Pizitz's Enchanted Forest; it also occupied considerably more space. Instead of a meandering path through snowy scenes, Santa's Station placed its displays in ten different decorated rooms. The first newspaper account described what could be seen in some of them:

> *Santa's Station gives an inside view into the life of Santa Claus through rooms decorated along such themes as "Santa's Living Room," "Santa's Bedroom," and "Santa's Village." In addition to Santa's living quarters, rooms will be decorated to look like the homes of some of Santa's favorite friends. There will be a "Doll Room," with dolls dressed to look as if they came from many different lifestyles; a "Train Room" with a large snow-covered train; a "Jungle Room" with little make-believe animals; and "Cinderella's Castle."*

One display not mentioned above was a room with a life-sized Nativity scene glowing under a black light, with a seemingly endless array of stars covering

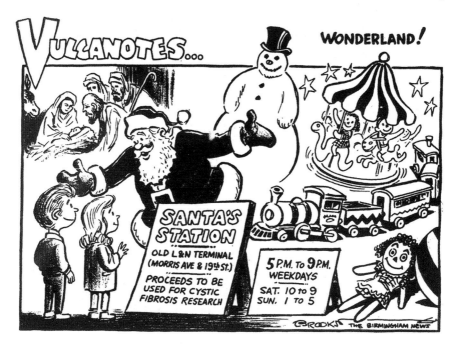

There seem to be no surviving photographs of the cystic fibrosis fundraiser known as Santa's Station, which inhabited the L&N Railroad depot on Morris Avenue in 1973, 1974 and 1975. However, this 1974 cartoon by Charles Brooks was a great depiction of how the attraction generally looked.

the ceiling and upper walls. Santa greeted kids in a large room—likely one of L&N's former meeting rooms—filled with animated figures and some of the large, lighted outdoor Christmas decorations that would soon be made obsolete by the price of electricity going berserk.

As a fundraiser for cystic fibrosis research, Santa's Station certainly did its best. In fact, it was successful enough to be repeated for the next two Christmas seasons. Not as many details were published about the 1974 and 1975 versions, but one element was singled out for special notice. Taking a cue from Pizitz's Talking Christmas Tree, one room in Santa's Station contained large replicas of those storybook favorites Raggedy Ann and Andy, who would talk to visiting kids through the efforts of an operator hidden behind a nearby screen. Although their mouths did not move, their arms could be made to wave via some nearly invisible wires.

It was the interaction between the raggedy pair and one of the young cystic fibrosis patients who came to see them (the attraction being as much to entertain such youngsters as to raise funds to fight the disease) that produced one of those "awww" moments that make Christmas so special. Seven-year-old Amanda Akers of Central Park was visiting Santa's Station at the same time as a *Birmingham News* reporter:

> *She had a good time posing for the photographer and carrying on her little conversation with the "voice" of Raggedy Ann and Andy. Then the photographer helped her down from her perch beside the dolls. She started to leave the room with her mother, Mrs. Doyal Akers. Then, completely unrehearsed, she turned around and went back and started talking again to Raggedy Andy.*
>
> *"Andy," she said, "Do you know why they've put up all these Christmas decorations?"*
>
> *"No, Amanda," replied the voice of Andy. "Why?"*
>
> *"They're to celebrate the birth of Jesus," said Amanda.*

Now, while you're busy getting some tissue to dab your moist eyes, let's travel along and look at what has become the only one of the Christmas celebrations discussed in this chapter that is still with us today. In the early 1970s, downtown Birmingham's long-standing skyline was noticeably altered for the first time in some fifty years thanks to the construction of some new skyscrapers. The three primary new arrivals were the South Central Bell tower, the Bank for Savings Building (with its rooftop marquee) and the structure jointly occupied by the First National Bank and Southern Natural

Gas, known by the acronym SONAT. It was this third one that made the biggest mark—in a quite literal sense—on Christmas.

The thirty-story SONAT building was designed in such a way as to be particularly impressive at night, with white fluorescent bulbs illuminating the entire structure and turning it into what Southern Natural Gas planned as a "Tower of Light." For the 1972 Christmas season, this illumination became

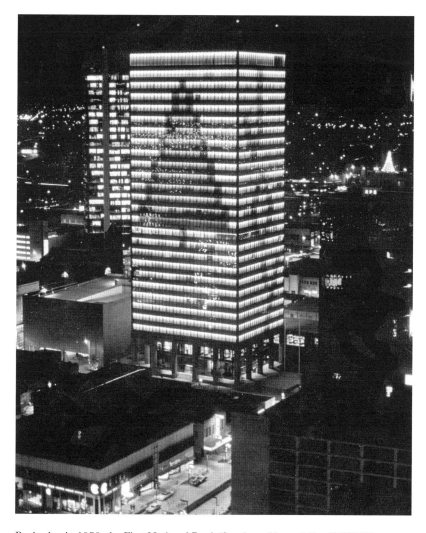

Beginning in 1972, the First National Bank/Southern Natural Gas (SONAT) Building displayed these Christmas emblems by inserting red or green sleeves over the fluorescent bulbs in some of its windows. More than forty years later, the tradition continues each holiday season.

the basis for a Christmas decoration to outshine all the others. Building superintendent Ollie Nix used a grid pattern of the building's windows to map out four holiday designs that would be created by slipping red or green sleeves over the fluorescent bulbs in selected windows. A tree, a stocking and a wreath (a somewhat distorted wreath, since it is difficult to create round shapes using straight lines…ask anyone who has ever played with an Etch-a-Sketch) became the staples of the yearly decorating. Additional designs were tried, including a bell that didn't quite ring true and three letters spelling the word *JOY*, but the *Y* was so low on the building that it could not be seen from afar. Nix finally settled on the lopsided wreath, the stocking and two trees instead of one.

The well-publicized (some might say overemphasized) energy crunch of 1973 nearly put out SONAT's lights for good. In fact, as of that year, the nightly illumination of the building was curtailed. But when the Christmas season rolled around, there was enough public sentiment that SONAT elected to turn on the red, green and white lights just for one month and then extinguish them once again. While the year-round lighting has yet to make a comeback, the Christmas designs remain as the oldest continuous Yuletide sight downtown.

During most of those years, and since the lights were not being used the other eleven months, the red and green sleeves would be left on the bulbs all year, thus saving the trouble of having to re-create the designs each fall. That is not the case today, as the building's current occupant, Regions Bank, has seen fit to come up with a few non-Christmas designs for other times of the year, most notably during the annual Regions Tradition golf tournament and campaigns for breast cancer awareness. But come November, just as sure as Santa has already been seated on his throne in the malls for weeks, one can expect to see the colorful Christmas emblems light up the night sky once again.

While the other downtown holiday sights have gone away, there were sporadic attempts to try to bring them back. After Loveman's closed its doors in the spring of 1980, the magnificent building sat vacant until being renovated into the McWane Science Center museum in 1998. Before that, Loveman's was one of a handful of downtown properties (others included the Alabama Theatre, the Burger-Phillips building and the Kress building) that fell under the control of the ill-fated Costa and Head partnership. This pair of entrepreneurs—Pedro Costa from Uruguay and Nelson Head from Birmingham—bought up as many dead and dying downtown buildings as possible with the noble intention of reviving the district. Unfortunately, the Costa-Head Company's eventual bankruptcy nearly spelled doom for its

holdings, the Alabama Theatre in particular, which came close to becoming a parking lot.

But in 1982, the Costa-Head plans still seemed to be workable, and that year, the company gave what it termed a "Christmas present for Birmingham." The Loveman's building was reopened for a day as the "Magic Place," hosting an array of performers ranging from magicians, bands and dancers to mimes, unicyclists and costumed characters who were unreasonable facsimiles of the Cookie Monster, E.T., Kermit the Frog and

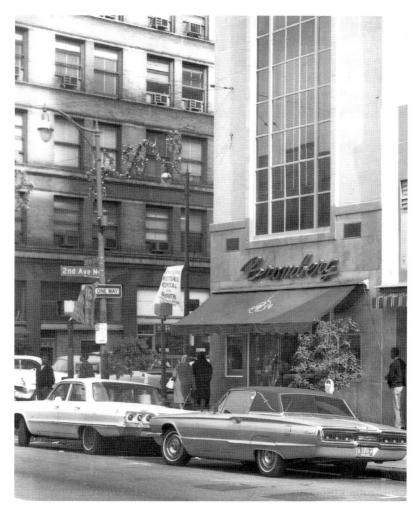

In 1992, Bromberg's Jewelers tried to recapture the magic of the old-time decorated Christmas windows. This photograph is from 1968, when we can see Bromberg's in juxtaposition with the hanging decorations over Second Avenue North.

Miss Piggy. Next door at the Alabama Theatre, an organ recital enabled folks to hear the roar of the Mighty Wurlitzer. Four years later, Costa-Head was bankrupt, few people remembered its lavish Christmas gift and downtown was darker during Christmas than ever before.

In 1992, Bromberg's Jewelers (by then one of the last remaining of the old-line downtown retailers) decided to try reviving the decorated window concept. The store's display artist, Charles Elliott, had formerly been with Pizitz and had worked with Jim Luker on the Enchanted Forest in both its auditorium and corner window settings. None of the original Pizitz animated figures were available, so Elliott rounded up some very similar ones belonging to Ed Cosby of Homewood's Ed's Pet World.

By the weekend after Thanksgiving, Elliott had transformed the large show window on the Second Avenue North side of Bromberg's into a close approximation of what people would have seen at Pizitz (or Loveman's) in the 1940s or 1950s. The reaction from the public was immediate. "Once I finished the window, the Brombergs brought a grandchild down. He was captivated. To see the joy and mystique of a beaming bright-eyed child—that's the beauty of it," Elliott related. He also noted that later that evening, at 11:00 p.m. on a Sunday, he drove by and saw cars stopped along the street and people standing on the sidewalk to gaze at the window. It was a small victory for those who enjoyed reminding people how things once were.

Since then, of course, downtown declined a bit further before beginning its slow but steady comeback around 2005. Today, with so many people living in loft apartments carved out of the former retail sites, Christmas decorations can be enjoyed once again, even if they are not due to the efforts of large display departments. The McWane Science Center sponsors annual holiday attractions designed especially for the Christmas season, so even the former Loveman's building can bask in a tiny bit of the glory it once knew. Today, more than ever, there is hope that the traditional downtown theater and retail district may not go away completely but simply be reincarnated in a different form.

ONE HUNDRED THOUSAND
TWINKLING LIGHTS

Besides all of the Christmas wonderment there was to behold around the big retail establishments downtown—both inside and outside—it was the city streets themselves that so many people remember with great fondness. The decorations erected by the city each year only served to enhance the store owners' individual efforts, and in fact, it was most often the combination of both that created the mental image of "Christmas downtown" that remains in people's minds.

As with so many other things that had no single controlling entity behind them, it is very difficult to trace the evolution of the city's decorations in the early days. Photographs from Birmingham's nineteenth-century Wild West–type era rarely show any decorations at all, the most famous exception being a decidedly unsanitary-looking establishment known as Gus Dugger's Saloon, from which a crudely lettered "Merry Xmas" banner hangs over the door. Other photos during the pre-1940 decades occasionally (and accidentally) captured some garland or other presumably lighted objects suspended over the streets, but they usually appear to have been something of an afterthought, more suited to a small-town Main Street than the retail hub of a major city.

On the other hand, the coverage given to these displays by the newspapers makes them sound considerably more impressive. At that time, photographic reproduction on newsprint still had a way to go in quality, so we are left with a thousand words to try to describe what could have been illustrated by a single picture. As an example, let us take the description of

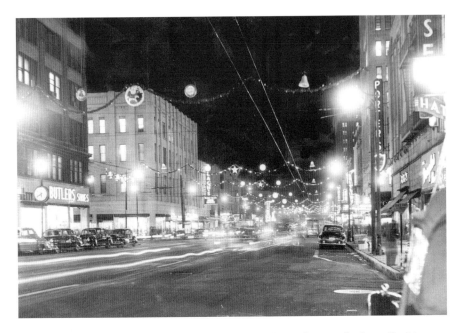

In this 1950s view of Twentieth Street, the Christmas decorations are fun but still a bit "small-townish" compared to what they would develop into during the following decade.

what was going to happen on the night after Thanksgiving 1931, certainly one of the worst years of the Great Depression. "The business section will be transformed into a fairyland of brilliance," the *Birmingham News* predicted. "Jimmy Jones, city commission president, will press a button that will illuminate thousands of lights on beautifully decorated buildings, and hundreds of Christmas trees studded with brightly colored bulbs." Elsewhere it was noted that "lights and garlands, both in profusion, have been utilized to make the streets and stores attractive."

(It was mentioned as something of a side note that the lighting of the decorations was only one feature designed to lure people downtown for special sales to "make Christmas shopping again a pleasure for those who have little money and desire to purchase many gifts." The Depression certainly had a stranglehold on Birmingham.)

A decade later, economic conditions had improved, and apparently so had the efforts to decorate the downtown streets. In 1940, the newspaper stated that the area from First to Fifth Avenues and from Eighteenth to Twenty-First Streets would be decked with 315 lighted decorations, and huge Christmas stars would be suspended over First, Second and Third Avenues and Nineteenth and Twentieth Streets. In another article, the

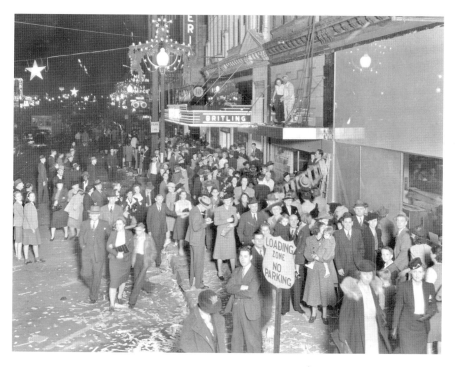

The photographer was trying to document the crowd awaiting the 1940 Christmas Carnival parade but did an even better job of showing us how the pre–World War II decorations on Twentieth Street looked at the time. *Birmingham, Alabama Public Library Archives, Catalogue #BN473.*

chairman of the street decorating committee, M.E. Walsh, mentioned that attached to the star-shaped ornaments would be fifty-nine thousand feet of Wisconsin balsam, certainly a different sort of approach from tinsel and artificial garland, although not nearly as long lasting.

Buried among all the plans was a reference to the "living Christmas tree" at Woodrow Wilson Park. This, however, was not the same as the living Christmas tree that would become such a centerpiece of downtown celebrations in the 1950s and 1960s (that will be coming up shortly). The 1940 reference was to a formation of thirty choirboys who would perform seasonal carols.

At some point shortly after World War II, the maintenance and installation of the downtown decorations became the responsibility of Bill Jenkins Sr., owner of a flag and decorations business. In 1987, *Birmingham News* writer Carla Caldwell caught up with Bill Jr., Jenkins's son, for a major interview about the family's long involvement in decking the streets. Bill Jr. was not certain just when

his father began his work with the city decorations, but he had clear memories of some of their adventures once he began helping his dad. "A long time ago, we would put colorful lights all across the streets," Jenkins told Caldwell. "When we were putting up the lights, we had to be very careful not to touch the trolley wires. Those wires were hot all the time, and the trolleys would come through while we were trying to get those lights up."

The city official who was in charge of the decorations was Al DeFuniak. His son, Fox DeFuniak, remembers that one of the biggest headaches associated with the job involved the way the decorations were hung. Rather than being attached to lampposts or other such handy structures, the decorations had to be mounted onto the exterior walls of the downtown buildings, which naturally involved getting permission from business owners who were understandably leery about having potentially damaging anchors affixed to their buildings. (DeFuniak said that, at least until so much renovation began taking place downtown in the mid-2000s, no doubt some of those scars would still have been visible.)

Now, about that "living Christmas tree" in Woodrow Wilson Park, like so many of the topics we are discussing here, there does not seem to be any definite documentation of when the tradition began. A photograph of the park that was published in the newspaper during the summer of 1947 clearly shows a rather small evergreen planted at the park's entrance facing Twentieth Street. By 1950, coverage was specifying the living tree as a thirty-five-foot cedar, and in 1953, the size was given as thirty feet. But it seems the city was having trouble with the "living" part of the tree's moniker. In 1956, newspaper coverage revealed that the current tree was the fourth to be planted on that spot during the previous five years but the only one to live.

By 1960, the pattern was set that would be followed for most of the next fifteen years or so: "First the tree will burst into jeweled colors," the newspaper predicted, "then a switch will turn on the thousands of multicolored lights and decorations along 'Santa Claus Lane' extending from Woodrow Wilson Park to Morris Avenue." This spectacular launch of the Christmas shopping season usually took place on the Friday night after Thanksgiving, but it tended to wander around the calendar over the week or so surrounding that date.

Although Christmas is supposed to be all about joy and love and peace and other such worthwhile topics, the hard fact was that it cost the city cold, hard cash to put on these elaborate displays. For several years in the mid-1950s, there seemed to be an annual crisis as to whether funds would be available. In 1953, Al DeFuniak reported that sufficient funds had been contributed by local business firms to cover the cost of that year's decorations. "The

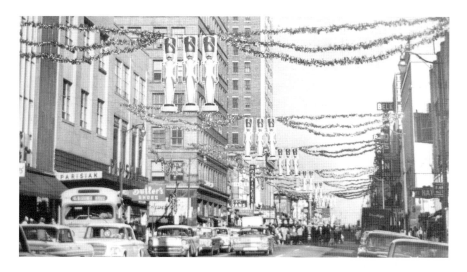

Above: The downtown street decorations really bloomed into their most elaborate form in the early 1960s. This circa 1962 photograph shows so many decorations overhead that the businesses along the street are almost hidden.

Right: The Downtown Action Committee went to great lengths to promote the central retail district as a magic land during the Christmas holidays, as seen in this 1962 ad masterpiece.

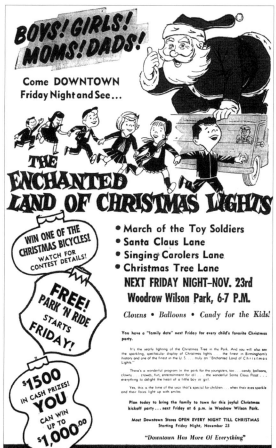

BOYS! GIRLS! MOMS! DADS!

Come DOWNTOWN Friday Night and See...

THE ENCHANTED LAND OF CHRISTMAS LIGHTS

WIN ONE OF THE CHRISTMAS BICYCLES! WATCH FOR CONTEST DETAILS!

FREE! PARK 'N RIDE STARTS FRIDAY!

$1500 IN CASH PRIZES! YOU CAN WIN UP TO $1,000.00

- **March of the Toy Soldiers**
- **Santa Claus Lane**
- **Singing Carolers Lane**
- **Christmas Tree Lane**

NEXT FRIDAY NIGHT–NOV. 23rd
Woodrow Wilson Park, 6-7 P.M.

Clowns • Balloons • Candy for the Kids!

You have a "family date" next Friday for every child's favorite Christmas party.

It's the yearly lighting of the Christmas Tree in the Park. And you will also see the sparkling, spectacular display of Christmas lights . . . the finest in Birmingham's history and one of the finest in the U. S. . . . truly an "Enchanted Land of Christmas Lights."

There's a wonderful program in the park for the youngsters, too . . . candy, balloons, clowns . . . crowds, fun, entertainment for all . . . the wonderful Santa Claus Float . . . everything to delight the heart of a little boy or girl.

Yes, this is the time of the year that's special for children . . . when their eyes sparkle and their faces light up with smiles.

Plan today to bring the family to town for this joyful Christmas kickoff party . . . next Friday at 6 p.m. in Woodrow Wilson Park.

Most Downtown Stores OPEN EVERY NIGHT TILL CHRISTMAS
Starting Friday Night, November 23

"Downtown Has More Of Everything"

Chamber plans to buy as much Christmas decorating material as possible, so future costs will be only for handling, storage and replacement," the *News* wrote in a hopeful tone.

That hope must have been getting dimmer by the following holiday season, because in October 1954 it was again being reported that whether the city would be decorated or not depended on who was willing to stand up for it. DeFuniak estimated that it would cost $12,000 to decorate downtown in the proper fashion, and the chamber of commerce had come up with only $6,500 of that. It was again going to be up to interested individuals and business owners to foot the bill for the rest. In pleading his case to the public, DeFuniak listed three primary reasons why the cost was so high:

> *Electrical current bill alone will be $1,000, since Birmingham has many dark days during the holiday season and Christmas lights must be kept on 24 hours a day;*
>
> *The decorations must be hung and hired by experienced labor* [this was no doubt where Bill Jenkins and his crew came into the story]*;*
>
> *and the whole project must be insured.*

Santa Claus must have been able to pull the remaining money out of his magic hat, because in 1954, 1955, 1956 and 1957 all of the usual activities went on. However, in the summer of 1958, the chamber of commerce decided it would drop downtown decorations completely and "confine activities to a promotion program," whatever that was supposed to mean. But by September, there had been a change of plans, and chamber chairmen Ralph Aland (of the New Ideal store) and Emil Hess (longtime owner of Parisian) announced that the decorations program not only would be continuing but also would be expanded.

Around the same time all of this was lighting up kids' faces and the city streets, a more short-lived tradition made its appearance. On Twentieth Street, a large float depicting Santa's sleigh and reindeer would pull away from the park tree at 7:30 p.m. nightly and carry loads of lucky kids down the busy thoroughfare and back again. Occasionally WBRC-TV personalities such as Benny Carle, Bozo the Clown (played by Bart Darby at that point in history) and the lovely Pat Gray would accompany the kids on their sleigh ride. All of this was well and fine, but it takes on a somewhat different shade when one learns that the individual who came up with the idea (based on a similar concept he had seen in Los Angeles) and operated the float was none other than Birmingham's now infamous

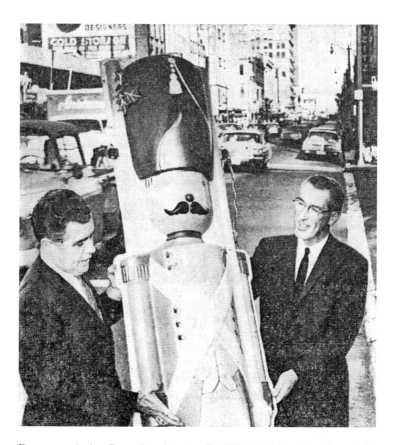

Downtown Action Committee honchos Ferd Weil (right) and Ira Capps (left) are seen in this "doctored" newspaper photograph inspecting one of the city's giant lighted toy soldiers. It appears that the pose of Weil, Capps and the decoration was placed against a file photo of Second Avenue North.

police commissioner Bull Connor. Perhaps that explains why this custom did not survive as long as some of the others.

By 1963, the year Connor made headlines of the sort no one really wanted, the Downtown Action Committee (DAC) had gotten into the Christmas spirit, taking over from the cash-strapped chamber of commerce, and it was under the DAC's direction by retailer Ferd Weil that the downtown celebrations really shifted into merry chaos. For that year's holiday season, dozens of new and more elaborate street decorations were purchased, and each street and avenue was designated with a different theme. Second Avenue was all aglow as Candle Light Lane, Third Avenue was to be known as Christmas Scroll Lane, Nineteenth Street was Santa Claus Lane and Christmas carols were the

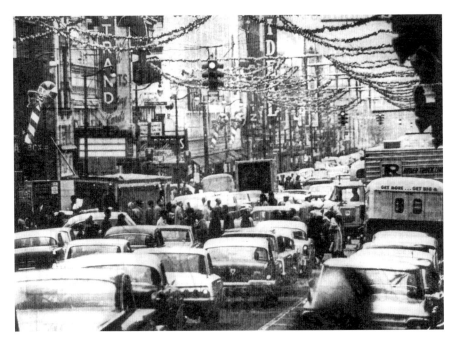

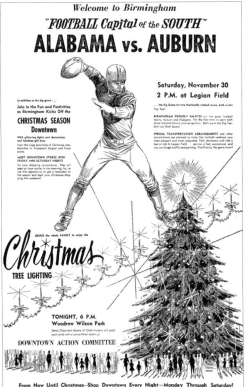

Above: This incredible view of Second Avenue North was published in the newspaper on Christmas Eve 1963, possibly the worst year Birmingham had known up to that time. It appears that the social upheavals of that spring and summer were sublimated for at least long enough to enjoy the downtown shopping experience.

Left: The weekend after Thanksgiving in 1963 must have meant some major crowds in town, with the Alabama-Auburn football game running headlong into the annual lighting of the city Christmas tree in Woodrow Wilson Park.

theme song for First Avenue. Twentieth Street was guarded by regiments of toy soldiers, each well over six feet tall.

Among all the usual holiday preparations in 1965, Al Rosenbaum of Fix-Play Displays donated a fifteen-piece life-sized Nativity scene for display in Woodrow Wilson Park. City recreation director Mary Gammon was quoted as saying that members of the DAC and chamber of commerce had dreamed of turning the park into a "winter wonderland" during the holiday season, and the Nativity scene would be the first phase of that. However, no photographs of the tableau seem to have survived.

The 1966 tree-lighting ceremony featured yet another new tree. It seems that the previous one had been planted at the entrance to the park in 1959, apparently replacing the 1956 model, but it had been damaged by the way the lights and ornaments had been attached to the branches over the past seven years. A new tree was rooted to the spot for the 1966 festivities, and damage was to be avoided by covering the tree in a framework that would hold the lights and decorations rather than hanging them directly onto the tree itself. This also produced a more pleasing and triangular silhouette for the tree when lighted at night. These new methods must have been what

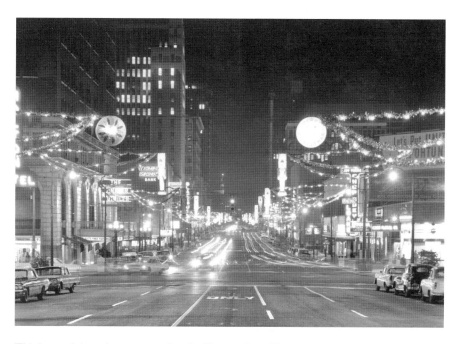

This is certainly a view to remember, looking south on Twentieth Street. By this time, the decorations no longer extended completely over the street, but downtown still looked like a Christmas fairyland to kids (and their parents, too).

were lacking all along, as the 1966 tree would be the one that survived for nearly twenty years.

In our next chapter, we shall see how, in 1966, the DAC began supplementing established traditions, such as the street decorations and the tree lighting, with an annual (for a few years anyway) parade featuring giant balloon figures. In 1967, the parade was to be held on a sunny Saturday morning, the tree-lighting ceremony having taken place the night before. Plans were announced to decorate every tree in Woodrow Wilson Park with tiny white lights, perhaps another phase of the "winter wonderland" concept mentioned a couple of years earlier.

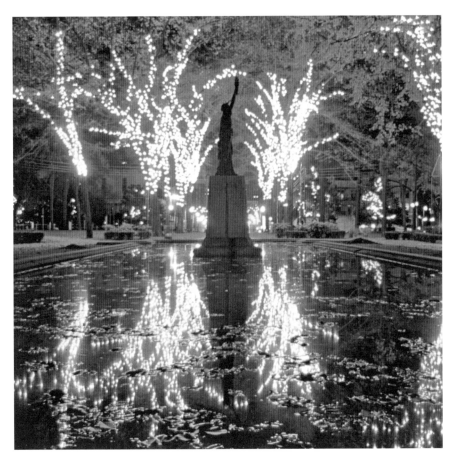

In 1968, the trees in Woodrow Wilson Park were bedecked with what was claimed to be 100,000 twinkling white lights. It made for a spectacular sight for many years, at least until the electrical cords began wearing out and fewer and fewer bulbs remained lighted.

Well, as it turned out, the best-laid plans of inflated balloon mice and DAC men go oft awry. The Friday night ceremony was washed out by heavy rains and rescheduled for Monday. The white lights to be placed on the trees somehow ran afoul of the city code. "We'll return the 100,000 small Italian lights to Nashville and try to come up with something for next year that will be acceptable to city inspectors," Weil was quoted as saying, no doubt between clenched teeth.

In 1968, the park finally got its 100,000 white lights in the trees, transforming the property into an awesome sight, at least for the next several years. The official press release that was sent out that year, credited to E.M. Dannenberg, gives perhaps the most complete description of the ceremony at its peak:

> *Children of all ages, by the hundreds, will flock to Woodrow Wilson Park at 6:00 p.m., Friday, November 29, 1968, for the annual "Living Christmas Tree" ceremony.*
>
> *The program, sponsored jointly by the Women's Junior Chamber of Commerce, Downtown Action Committee and the Birmingham Area Chamber of Commerce, will have a background of 100,000 tiny lights glowing in the park.*
>
> *Workmen from the Park Board are busy putting on the Christmas tree decorations provided by the DAC and the Chamber. Mrs. Mary Gammon is in charge of the tree decorations. The "Living Christmas Tree" was bought by the Women's Chamber of Commerce several years ago.*
>
> *Mayor George Seibels will bring a greeting on behalf of the city, after the opening prayer by Dr. Herbert Gilmore, pastor of the First Baptist Church. Dr. Denson Franklin, pastor of the First Methodist Church, will offer a special prayer.*
>
> *Mrs. Charles Lamar, president of the Women's Junior Chamber of Commerce, will bring a special greeting from that group. Mrs. A.G. Gaston will speak for several Negro organizations.*
>
> *The Chamber will be represented by John E. Steger, Chamber executive vice president, and Ferd Weil Sr. will speak for the Downtown Action Committee.*
>
> *Radio and TV personalities will be on hand, including "Cousin" Cliff Holman, "Sergeant Jack," and Neal Miller, to take a walk down "Santa Lane," passing out candy to the children.*
>
> *Joe Turner, Woodlawn High School music director, will lead the singing of Christmas carols and the ROTC unit from that school will help with the crowd.*

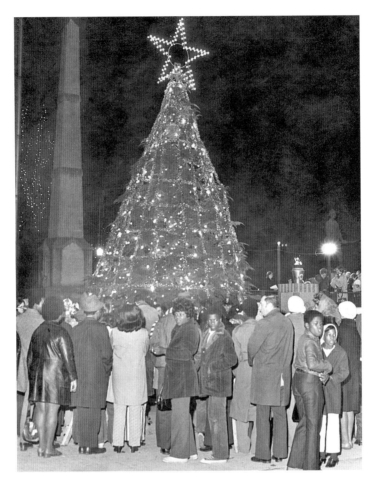

This early 1970s view of the annual tree-lighting ceremony clearly shows the framework on which the multicolored lights were placed. Rather than attaching them to the branches of the tree, decorators used the framework to protect the tree. Besides being less wear on the living tree, it provided a more pleasing triangular silhouette when viewed from a distance. *Birmingham, Alabama Public Library Archives, Catalogue #1556.36.95.*

Several special musical features this year will be Shawn Muir, 12-year-old blind youngster, playing Christmas carols on the program, and the "Sing Out Birmingham" group of young people in a series of Christmas carols.

On hand to entertain the youngsters pending the arrival of Santa in a big red fire truck will be "Kookie the Kops" in their old time police uniforms with their own special musical equipment, this group having appeared in parades over the entire South.

Yes, it seems obvious that by 1968, speeches from all the different officials involved took up more time than the actual Christmas celebration. The most amusing piece of that press release, however, is in the paragraph about the TV personalities. In case you didn't catch it, Neal Miller *was* Sergeant Jack; seeing both of them together would have been somewhat like finding Superman and Clark Kent in the same room at the same time.

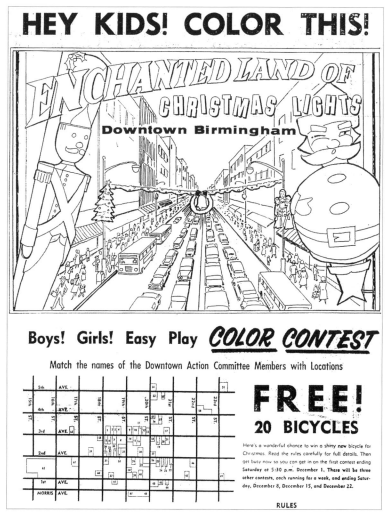

The Downtown Action Committee was at it again with this 1962 coloring contest. Youngsters were encouraged to learn the locations of all the participating downtown businesses by pinpointing them on an associated map.

While the tree-lighting ceremony remained pretty much the same from year to year, with only the names of the officials and participants changing, in the rest of downtown things were starting to evolve by the early 1970s. Bill Jenkins and his crew kept up their enjoyable annual ritual of hanging the decorations just prior to Thanksgiving. By that time, they were finally being attached to lampposts rather than to the skin of the buildings, and at the same time they began to shrink somewhat, in both size and complexity.

In the aforementioned 1987 newspaper interview, Bill Jenkins Jr. mentioned that in the early 1970s, a law was passed that prohibited the Christmas decorations from extending over the street. His theory was that this was done because people could not distinguish the Christmas lights from traffic lights. Perhaps this was true, but since people had been faced with both forms of illumination at least since the 1920s, it seems improbable that it could have become a crisis so suddenly. Then again, maybe people were just dumber in 1972 than they used to be.

Just as likely, the change in decorating style might have had something to do with the efforts to beautify downtown, such as the much-lauded Birmingham Green project that transformed Twentieth Street, long downtown's primary north–south corridor. Looking back, it seems that practically everything that was done to create Birmingham Green was intended to bring it closer in spirit to the shopping malls that were sapping business from the downtown district. From the reduction in traffic lanes putting more emphasis on pedestrians to the greenery that obscured store signage unless one was standing right in front of a business, the new mall-like face of downtown just no longer seemed conducive to decorations that could be seen stretching for blocks.

Whatever the reason, overhead hanging decorations were out, and "pole decorations" were in. With all his years of experience, Bill Jenkins decided that if new decorations were what were needed, he might as well craft them himself. The tinsel-shaped stars and candy canes he made to hang from lampposts throughout downtown were certainly not as flashy as the old decorations had been, but at least they met the new legal and aesthetic criteria.

Jenkins's new decorations made their public debut at a rather odd time of year. During July 1973, selected examples of the new holiday finery were suspended from poles along Twentieth Street, the official reason given being "to see if the old brackets are sturdy enough to hold them." Both brackets and decorations passed their test and were put away to await November, but before the Christmas season proper could arrive, something else happened that would affect them.

If you were alive and conscious during that year, you will remember a little national scare called the energy crunch. Unrest in the Middle East forced gas prices to what were then thought to be astronomical prices (citizens of the twenty-first century would kill to have those prices back), and the always reliable (to whip up a national crisis at the slightest provocation) federal government built it into a fear that the United States was running out of energy. Part of that was a request from President I-Am-Not-a-Crook Nixon for people to not use electricity to power Christmas decorations that year and to keep their homes colder in order to conserve heat.

So it was that on the night after Thanksgiving, the Living Christmas Tree lit up as usual, and Bill Jenkins's new garland-covered stars and candy canes glowed on each lamppost. But one week later, everything was unplugged and left dark for the rest of the season. The most evocative description of that very strange Christmas was penned by *Birmingham News* writer Garland Reeves and was published on Christmas Eve. Here are a few excerpts:

WE PUT THE HAPPY INTO THE HOLIDAYS!

Be downtown at Woodrow Wilson Park on Friday, November 24 at 6 p.m. for the Christmas Tree Lighting. See thousands of lights transform the park into a sparkling fantasy-land. Laugh at the clowns. Hear the music. Meet the popular personalities who will be there. See the fabulous Santa Claus float cruise down Twentieth Street every evening from 6:30 to 8:30 p.m. starting Monday, November 27. Catch the goodies St. Nick tosses to his little friends. Ride down brightly decorated streets (all open to traffic) and admire the scintillating show of lights and color in the store windows. Stop in a con- venient parking place. Dash into the stores to see what's there for you to give and to get.

Choose presents, toys, amusing stocking stuffers from an unlimited variety provided by Downtown Stores. Special prices and special purchases can help to make your dreams come true.

Remember that most stores are open extra hours so there's plenty of time to shop.

Relax and enjoy the entertainments provided by theatres, restaurants, snack bars and lounges.

Share the most exciting days of the year with your family and friends in . . .

Alabama's Largest Shopping Center Downtown Birmingham

The Downtown Action Committee was fighting a losing battle against the suburban malls and shopping centers, but as we can see here, in 1972 the DAC was still whistling past the graveyard and trying to get as many people as possible back to the city center.

It's going to be a little colder, a little darker for Christmas in Birmingham this year. A reminder of just how small and limited this little hunk of dirt is. Half a world away, people get angry at each other and our lights are dimmed.

Last year, Woodrow Wilson Park was a fairyland of dancing lights. This year the trees are naked shadows. On Birmingham Green, red and white stars swing from modernistic street lights. They remain dark. And in a hard wind, they sway back and forth, the plugs, unplugged, banging a tune against the lamp standards.

Still, there is that special warmth and genuineness about Christmas that makes men better. For want of a better word, call it love.

With or without lights and heat, Christmas is special. It was 2,000 years ago. It will be this year. It always will be.

Well, by the next Christmas, that particular energy crisis had been forgotten, the president who had put so much emphasis on it was out of office and things seemed to be back to normal—at least on the surface. Historians often discuss the rest of the 1970s with the term "malaise," meaning that the United States seemed to be adrift with no real enthusiasm for where it was going. That feeling may or may not have had anything to do with an announcement that came out in November 1975.

As of that year, the newspapers reported, there would no longer be a ceremony connected with the lighting of the Living Christmas Tree. The tree would still be decorated as usual, but instead of gathering around the cedar for a nighttime event, festivities would be held at the Alabama Theatre on the Saturday morning after Thanksgiving. The official reason given was "to avoid having the large numbers of children standing outside in the park in weather that is oftentimes very chilly." Like the earlier reasoning that people could not tell Christmas decorations apart from traffic signals, this excuse seems to have holes in it the size of the one in the top of Vulcan's head, but be that as it may, the tree-lighting ceremony was to be relegated to the past.

Or was it? There are photographs from early December 1976 that show a wooden platform erected next to the tree, just as it always was when the ceremonies were being held. In 1978, the newspaper reported on yet another Saturday morning party at the Alabama Theatre, "an outgrowth of the Christmas tree lighting in Woodrow Wilson Park, which used to happen the night after Thanksgiving." Yet during Thanksgiving week of 1979, this curious news item appeared:

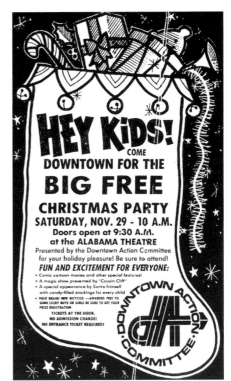

Right: One of the first long-standing downtown Christmas traditions to fold was the ceremony surrounding the lighting of the tree. This 1975 ad tried to put a happy face on the ceremony's theoretical replacement, a Saturday morning program held at the Alabama Theatre.

Below: This photograph has a mystery associated with it. It was made in early December 1976, a year when, according to all sources, there was no tree-lighting ceremony. Yet a stage/reviewing platform was set up next to the tree, just as in previous years. Why? No one seems to know.

If you have some out-of-town company with young children around the house and they have a yen to do something exciting during their visit to Birmingham, the annual Christmas tree lighting in Woodrow Wilson Park could fill the bill. Every year on the Friday night after Thanksgiving there's a big festival in the downtown Birmingham park to usher in the fast-approaching Christmas holiday season.

The short piece went on to describe the musical acts and so on, as if the ceremony had been going on every year without interruption. Whatever the story may be, once the ceremony was reinstated, it has not gone away since. There was more drama to come, though, so don't settle down into that easy chair by the stockings-bedecked fireplace just yet.

While festivities came and went (and, apparently, came again), the park in which they took place was having its own aging problems. Remember when those 100,000 twinkling lights were installed back in 1968? Well, those same strings of sockets and bulbs had been left in place ever since, and by 1978 it was the responsibility of city electricians J.B. Latta and Gene Waldron to keep them burning. That was not as easy as checking the bulbs on your Christmas tree at home because not only were the electrical cords stretched and broken by the growth of the trees, but Latta also noted that the park's squirrels seemed to have a particular penchant for gnawing through them. "I think they do this out of boredom. They just don't have anything better to do," he remarked.

By that point, about half the original number of lights were still working, spread throughout approximately fifty-five trees in the park. An article in October 1978 mentioned the now rather obscure fact that even though the lights' primary purpose was Christmas, there were other nights throughout the year when they would be turned on as well.

The tree-lighting ceremony certainly had some big-name talent for the 1982 event. Norma Zimmer, of *Lawrence Welk Show* fame, was in town for the annual Festival of Sacred Music and did the honors of lighting the tree. Also on hand were other famed musical personalities in town for the festival: Bob Ralston, Christy Lane and Danny Gaither. But the park where they were helping out was a far different place than it had been just a few years before.

After J.B. Latta's retirement, maintenance on the park lights had become more and more hit-and-miss. A couple of weeks after Champagne Lady Zimmer brought her bubbly personality to the annual event, another newspaper article focused on the sorry state of the lights. As writer Kitty Frieden so picturesquely put it, "The thousands of white tree lights that used

to transform Woodrow Wilson Park into a twinkly fairyland now resemble a cornfield that's been attacked by a flock of crows." By that point, parks maintenance director Jim Rotenberry estimated that about 40,000 of the 100,000 lights were still working. He explained that replacing burned-out bulbs was not the main problem; it was the broken electrical cords, rapidly losing their battle with squirrels and tree growth.

One excuse given for not spending the necessary funds to repair or replace the formerly impressive display was that a new volunteer group, Friends of Woodrow Wilson Park, had been formed to look into renovating the downtown showplace, and it was possible that another lighting system would replace the 1968 decorations.

By the summer of 1984, those plans had progressed into an entire rethinking of the park, including changing its name. Several articles attempted to explain why, for once, tradition should not be a consideration. To put it briefly, the green space was originally called Capitol Park because there was an overly optimistic feeling that eventually the state capital would be moved from Montgomery to Birmingham and the park would adjoin the theoretical new capitol building. When that didn't happen, during World War I the park received its new name in honor of then current President Woodrow Wilson, who may or may not have ever known about that honor. Because its two previous names had turned out to have no connection with Birmingham whatsoever, the thinking among the volunteer group was that the park should be named for early Birmingham business pioneer Charles Linn.

While plans proceeded apace, shortly after the 1984 tree-lighting ceremony there was some news that might not have come as a surprise to anyone who had been paying attention. The plans for the renovated Woodrow Wilson/Linn Park were said to not include the living cedar tree, which had become infested with disease and was actually dying from the top down. Anyone who saw the tree, stripped of its holiday décor, during this period could easily recognize that it no longer presented an attractive appearance. The Friends of the Park group, headed by Temple Tutwiler III, also wanted a clearer view of the park entrance from Twentieth Street, and since at least 1950, there had always been a tree blocking that line of vision. While acknowledging that the tradition of a downtown city Christmas tree should be preserved, those in charge ultimately decided the diseased eighteen-year-old cedar had to go. It was unceremoniously cut down sometime in the summer or early fall of 1985.

During the 1985 Christmas season, the populace was assured that the lighting ceremony would resume in 1986, "after a more disease-resistant tree is

Birmingham still has a Christmas tree in Linn Park (formerly Woodrow Wilson Park), but it is a temporary installation. The living, growing, 365-days-per-year tree was cut down in 1985 due to disease.

planted." Actually, the idea of a permanent, growing Christmas tree had already been discarded in favor of the method used by other large cities, most notably New York's famed Rockefeller Center. Rather than a year-round tree, one would be purchased and erected for each holiday season, approximately on the same spot where the original had stood. This was considered important enough to be included in the actual construction plans for the park. Today, Temple Tutwiler recalls:

We knew we wanted to make it so that a Christmas tree could be placed there every year during the holidays. We needed some sort of heavy-duty sleeve set deep in the ground as a permanent tree stand. I called Philip McWane and asked him if he had a scrap piece of pipe we could have for this, and he said that if they didn't, he'd just cut us a section out of a good one…any diameter and any length. He even delivered it. A very good guy!

On Christmas Eve 1986, the Birmingham City Council voted (7–2) to change the name to Linn Park; along with the new, temporary tree each year, it represented the final break in the long tradition. Needless to say, what was left of the 1968 twinkling white lights was removed during renovations too, although, considering how those strands of bulbs were intertwined in the branches of the trees, it is not inconceivable that some fragments of them might still be found if one searched in enough out-of-the-way gnarled nooks.

Out on the streets, Bill Jenkins had died in 1984, and Bill Jr., his son, and Charlie, his grandson, had taken over the job of installing the pole decorations. They continued to use Jenkins Sr.'s stars and candy canes crafted in 1973, but during Bill Jr.'s final season on the job, 1987, the Downtown Action Committee did spend some $4,800 with Fix-Play Displays to add some new lighted ornaments. After Bill Jr.'s retirement, workers from Stone Electric Co. (which had long supplied the necessary equipment anyway) took over the decorating responsibilities.

Without the Jenkins family's longtime personal commitment, the street decorations went into the same downhill slide as the long-gone twinkling lights in the park. By 1996, a newspaper feature about the ornaments' condition was subtitled "O Tattered Stars of Birmingham." Writer Benjamin Niolet didn't pull any punches:

Birmingham's downtown holiday decorations are—ahem—modest.
OK, they're understated.
All right, they're bad, city officials, business owners and pedestrians agree.
Every year, Birmingham employees mount shimmery stars and stockings from utility light poles throughout the downtown area. Every year those decorations seem to have fewer working light bulbs and seem a bit more scruffy. It's getting harder to pretend the decorations are pretty.

As always, money was the Grinch that was stealing downtown's Christmas cheer, although to be honest, by that time there were none of the large

Today's downtown street decorations are incredibly simple, quite a change indeed from the days when they stretched overhead for as far as the eye could see.

businesses left that had once made the area a holiday shopping destination. Eventually the last of Bill Jenkins's tinsel stars was retired, and today, the street decorations are so subdued as to be barely noticeable. And keeping with tradition, some of their bulbs work while others are left in their burned-out state.

Perhaps the most memorable event to happen to the downtown displays in recent years occurred a little over a week before Christmas 2010. During the

wee hours of the morning of December 15, would-be copper thieves crept up to that year's tree in Linn Park, removing light strands and using gasoline to try to separate the plastic from the copper. Probably inadvertently, that set off a blaze that reduced the tree to a pile of ashes, its only remnant a charred stump anchored in the McWane pipe deep under the sidewalk.

Initially the city declared that with only ten days left before Christmas, there would be no replacement tree, but before that day was over, radio station WBHK ("Kiss FM") had paid the necessary costs for bringing in a new tree and furnishing it with lights and decorations. The torched tree had been a thirty-five-foot Norwegian spruce from North Carolina, but the replacement was a forty-footer from Tarrant, somehow making the victory that much sweeter. (It was certainly a good thing an incident like this did not occur while the living, growing tree was a year-round sight in the park, as replacing it in such a short time would have been much more difficult.)

And so, it appears that through whatever financial crises, neglect or plain old crime has plagued them, the city-sponsored downtown decorations have refused to stay packed in a box in some warehouse. We can hope they will always continue in one form or another, even if not as spectacularly as in the 1950s and 1960s. That was a different era, any way you look at it, and just like the city of Birmingham itself, its holiday finery has had to evolve with changing times, tastes and demands.

LET'S HAVE A PARADE

B irmingham has had a number of parades that became annual traditions, two of those being the Veterans Day procession and the march preceding the Magic City Classic football game. But while many other large cities found equal success with Christmas parades, somehow Birmingham never seemed to develop one that would last more than a few years before fizzling out, only for the idea to be revived again by (perhaps) unwitting successors.

The earliest known Birmingham Christmas parades do not seem to have been planned as recurring, annual events. As a completely random example, let's take Thanksgiving Day 1931, when the *Birmingham Post* newspaper (long before becoming the *Post-Herald*) sponsored a nighttime parade. Not many details were provided about it, and another pair of parades the same day got a whole lot more coverage. That was the day the long-awaited Twentieth Street underpass opened, eliminating a major railroad crossing, and two parades commemorating the event—one traveling north to south and the other south to north—drew more attention than the *Post*'s procession.

The sketchy coverage that 1931 event got sometimes referred to it as both a "carnival" and a parade. This idea must have caught on, because in 1935, a full-fledged Christmas Carnival was launched, a three-day affair beginning on Thursday, Thanksgiving Day, and continuing through Saturday. A parade (or sometimes more than one) was an expected and prominent part of the first carnival and would remain so in future years. The 1935 event saw the crowning of the first king and queen, King Cheer I and Queen Joy I, and their float in the parade was provided by the *Birmingham News*.

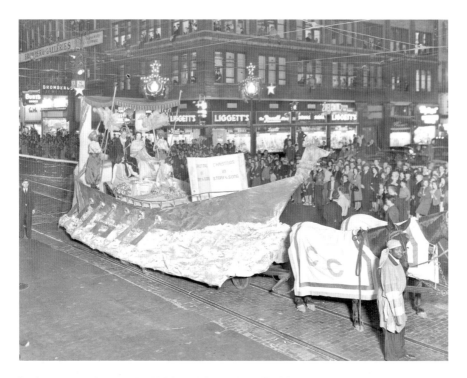

In the 1930s and 1940s, the highly anticipated kickoff of Birmingham's holiday season was the Christmas Carnival. Here, circa 1940, King Cheer and Queen Joy are ready to reign over the proceedings from their float fit for royalty. *Birmingham, Alabama Public Library Archives, Catalogue #BN476.*

By 1940, the Christmas Carnival was running like a sleigh on well-oiled runners. The ads that year gave an idea of what sort of fun was to be had in those final innocent days before World War II:

> *It's Carnival Time in Birmingham! Beginning Thursday, the city will ring with merry-makers. Features of the carnival will be the crowning of the King and Queen of the Carnival, a great Street Dance, the Coronation Ball at which princesses from all parts of the state will be presented, the lighting of the Community Christmas Tree, the night Christmas Parade, special displays of holiday styles and Christmas merchandise, and of course, football. Howard College will play Spring Hill on Thanksgiving Day and Alabama will play Vanderbilt on Saturday.*

(Does it sound odd that the big football deal for that weekend did not mention anything about Alabama and Auburn? Remember that in 1940

that famed rivalry was still on hold; it would not resume until 1948, after which it would become an integral part of the post-Thanksgiving weekend in Birmingham.)

At least if the newspaper publicity is to be believed, Birmingham's Christmas Carnival extended its influence far beyond the city limits. It was reported that "several large delegations, representing other Alabama cities and neighboring states," would be in town for the three-day celebration. As for the parade, the crowd was expected to reach some 200,000 souls lining the downtown streets.

Surviving photographs from the period show that the parade had a decidedly "homemade" look to it, which of course was completely fitting for Christmas—at least as it was celebrated in the South at that time. The floats generally resemble creations that could have graced a larger high school's homecoming parade and, as one would expect, ranged from depictions of Santa and his sleigh to variations on the traditional Nativity scene, complete with what appear to be papier-mâché camels. Naturally, the most elaborate

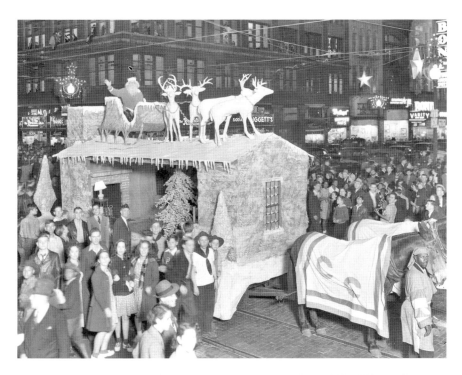

No Christmas Carnival parade would have been complete without jolly old Santa Claus comin' to town, and this was his sleigh team in the early 1940s. *Birmingham, Alabama Public Library Archives, Catalogue #BN477.*

float seems to have been reserved for King Cheer and Queen Joy—with, not surprisingly for the late 1930s and early 1940s, African American attendants leading the horses that pulled the float and fanning the royalty with large feathered fans.

During Thanksgiving week 1941, Birmingham geared up for its last prewar Christmas Carnival, but this time, things were a bit less carefree. Although the United States had not officially become a part of the conflict that engulfed the rest of the world, there was sufficient evidence that things were heading in that direction. Beginning on November 4, the entire downtown area was subject to a blackout, ostensibly to help save power for defense, but such procedures were also familiar in cities that were considered targets for nighttime enemy attacks. The prohibited uses of electricity included neon signs, show windows, ornamental lights, field lighting for sports and any interior or exterior lighting for advertising purposes.

This was certainly going to make the annual downtown parade much grimmer than usual, making its way along darkened streets, but a bit of good news three days before the parade made things sound a little brighter. Public safety commissioner Bull Connor and C.S. Thorn, vice-president of Birmingham Electric Company (BECO), jointly issued an "all clear" for three hours on the Friday night after Thanksgiving, during which the downtown neon signs and show windows would be allowed to shine for the duration of the parade. But Connor and Thorn had failed to reckon with the federal government. On the morning of that Friday, BECO was forced to issue another statement:

> *We have been advised this morning by the Office of Production Management that show window and other prohibited lighting MUST NOT BE TURNED ON TONIGHT during the Christmas Carnival parade. We are taking this means of notifying our customers of this OPM order, and know that they will continue to cooperate as they have in the past, so there will be no impairment in the National Defense effort.*

And so that year's parade groped its way through the dark, making one wonder how the people along the sidewalks even managed to see the floats and other units. Shortly thereafter, BECO was able to take out another newspaper ad depicting Uncle Sam slapping Reddy Kilowatt on the back and proclaiming "LIGHTS ON! All power restrictions lifted!" and encouraging people to "Come downtown tonight! See the lights and do your window shopping!" The ironic thing about the timing of this ad is that it ran on Saturday, December

6. The next day, of course, there would be a certain sneak attack on a certain U.S. military installation in Honolulu, and afterward, blackouts would come to be the norm rather than a temporary inconvenience.

And so came three Christmas seasons, 1942 through 1944, during which the world was at war and celebrations were low-key, if they were held at all. The fighting ended in August 1945, meaning that year's holiday season was the first peacetime one since 1940. (New York children's radio show host Uncle Don, in remarking on the end of hostilities that summer, offhandedly mused that some of his younger radio listeners had never known anything but war during their short time on the planet. "Well, there's a lot more to life than war," he assured them, "a LOT more.") People were so anxious to get things back to normal that the postwar years are still legendary for their unprecedented sense of prosperity and optimism, and that included Christmas.

The Christmas Carnival would be vastly different in 1946. It was Birmingham's good fortune that the kickoff of that year's Christmas season coincided precisely with the seventy-fifth anniversary of the city's founding, so the festivities stretched to the entire Thanksgiving week, proclaimed as Birmingham's "Diamond Jubilee."

That 1946 parade included not only the traditional Christmas-inspired floats but also ones depicting landmarks in Birmingham's seventy-five-year history—attention to accuracy not necessarily being one of the main concerns. There was another event taking place on Thanksgiving night, however, that in retrospect seems like a false start for a concept that would return twenty years later. The newspapers referred to it as the "Children's Parade" and announced that it would include more than thirty "balloon animals," including Philly the Fish and Doodles the Bug, plus other more humanoid figures. Wouldn't one expect the media coverage to make comparisons to that bigger event featuring giant balloons that had taken place way up in New York City that same morning? Ah, but you forget how different things were in 1946. In those pre-television days, few people outside the NYC metro area had ever heard of Macy's Thanksgiving Day Parade, unless they happened to catch a few clips from it in a weekly newsreel at the movies. No, that parade was not the national institution it would become later.

(That brings up another point. Although *Miracle on 34th Street* is today considered an all-time classic Christmas movie, with its footage of the 1946 Macy's parade, the 20th Century Fox studio chose to release it in, of all the inappropriate times, June 1947. The movie played at the Alabama Theatre late that month, and the ads appearing in the newspapers gave absolutely no indication that it was a Christmas-themed film. Some of

'Come In!'

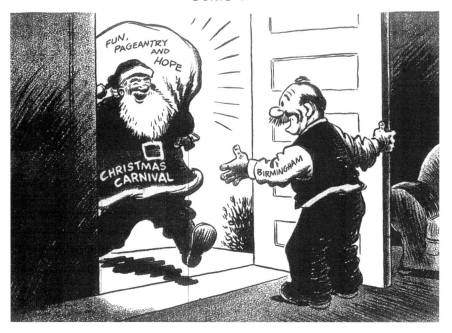

Charles Brooks captured the anticipation of the Christmas Carnival in his 1949 cartoon on the subject.

the posters and ads included very incidental artwork of the parade but emphasized only stars John Payne and Maureen O'Hara—Edmund "Kris Kringle" Gwenn in a microscopic photo, seen only from the back—and the description sounds nothing like the story millions have come to cherish: "In this picture you'll see yourself! It's like looking in a mirror…You'll meet the real people in life—its story is your story…your dreams…your disappointments. Sometimes it's funny…sometimes it's sad…but when it's over, you'll agree you've seen a whale of a picture!")

After 1946, the Children's Parade became an annual event, too, but apparently the balloon creatures were not invited back to town—at least not for a while. Instead, future installments would boast floats made by various schools in the area. In 1949, the theme was the "Land of Music," and each school picked an appropriate song for its float. Proving that things had not made that much progress since the prewar days, Powell School's float based on "Dixie" had not only a student dressed like a southern belle but also other students in minstrel-style blackface to pull the float. Ah well, that was 1949 for you, folks.

At some point during the Korean War, the idea of the Christmas Carnival and its accompanying parades seems to have melted away like a Birmingham snowfall. But there were outlying communities that took up the challenge and created some incredibly elaborate processions of their own. In the mid-1950s, Ensley's parade looked a whole lot like what had been seen downtown in previous years, with the same types of floats and representatives from the many local schools and colleges. The 1955 Ensley parade had a rather split personality; while the fifteen floats all stressed a religious theme ("the manger scene, the cross, shepherds, angels, and so on," as the newspaper described it), Santa Claus made his appearance by riding in on a fire truck. Notwithstanding Santa seemingly being the only secular element of that year's parade, it is notable that none of the earlier downtown parade coverage mentioned him being part of it at all, other than being portrayed "unofficially" in some of the floats.

The idea of a downtown parade came creeping back in 1964, but in a different way. As part of the ongoing "Toys for Tots" campaign, a parade was staged in mid-December under the joint sponsorship of the Marine Corps Reserves, the Fraternal Order of Police, Shell Oil Company and WBRC-TV, which used its influence to bring in ABC network personalities Eileen O'Neill of *Burke's Law* and Ed Norton of *Peyton Place*. Again, jolly old St. Nick was there, riding along with champion blind golfer Charlie Boswell.

As we saw in earlier chapters, the Downtown Action Committee had been formed to find ways to attract more people to the city center, although a casual glance would not have given the impression that anything needed to be done. Along with making the annual Christmas tree lighting into a big affair, the DAC in 1966 announced that on the night after Thanksgiving there would be an enormous "balloon parade" through the downtown streets—and by then, there was no hiding the DAC's intent to out-Macy Macy's, if not with the size of its balloons, at least in sheer numbers.

The biggest difference was one that was mentioned only as a footnote in all the pre-parade hype. Birmingham's streets, with their overhanging power lines and traffic signals, were not conducive to the floating, helium-filled characters for which Macy's was so famous. Instead, the balloons seen in the DAC's parade would be mounted on platforms and wheeled along the parade route. The city rented the inflatables from a Pennsylvania company known, not surprisingly, as Giant Balloon Parades, Inc. According to parade balloon historian Bill Smith, this company was founded by Joseph Sonneborn in the late 1930s and had been providing its ground-based giants to local parades ever since.

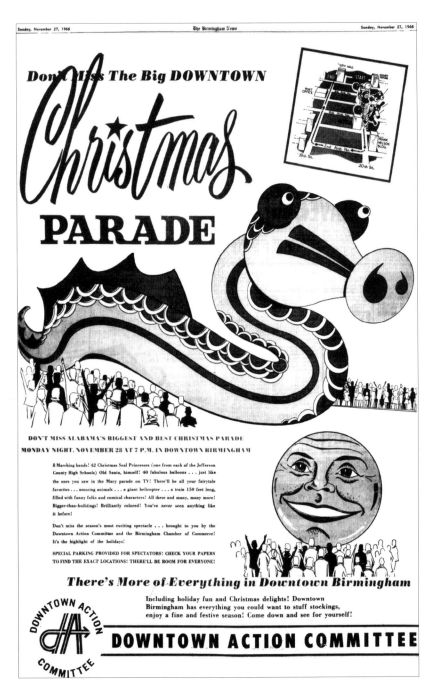

After more than a decade of no official Christmas parade, the Downtown Action Committee revived the concept in 1966, this time putting the emphasis on giant balloon figures of the type popularized by Macy's Thanksgiving Day Parade.

It was announced that the first giant balloon parade would carry a "Fairyland" theme, with figures representing such classic characters as Peter Pan and Captain Hook, Beauty and the Beast, Snow White and her seven vertically challenged companions, the Man in the Moon and most of the Mother Goose crowd. Along with nonliterary sights, including a 150-foot train with gleaming teeth, there would be some interlopers not normally associated with Christmas, such as a fearsome vampire and Frankenstein's monster. The platforms would be drawn by *Birmingham News* carriers, and music would be provided by the high school bands from Mountain Brook, Fairfield, Banks, Berry, Hueytown, Tarrant, Carver and Abrams. Not surprisingly, DAC chairman Ferd Weil himself would be grand marshal and lead the head of the parade.

From the reports, it was obvious that the excitement of this parade was directly dependent on whether one was viewing it as a child or an adult. The next day, the *Birmingham News* gave an estimate that 100,000 people had lined the sidewalks to watch the parade's inaugural run. Staff writer Hugh Merrill, however, chose to concentrate heavily on how worn-out the balloons appeared. "Loud squeals of snaggled-tooth delight vibrated from taut, unripened vocal chords," he wrote, "and as the brisk wind whipped rosy cheeks into apples, the past-their-prime balloons began to take on the look of magic. At least for the children." Merrill had no trouble finding adults to agree with him, as one lady commented on the decidedly ugly characters, "They have the most horrible expressions on their faces."

Ferd Weil and his cronies didn't have horrible expressions on their faces, though, and the event was deemed enough of a success to make it an annual affair. The 1967 parade was held on a sunny Saturday morning, perhaps in response to the chilly nighttime temperatures of the previous year. Some of the same balloons returned for encores, but in general, the figures selected for 1967 seemed to follow a biblical theme. This would not have been unusual, as evidenced by the many religious-themed floats from past parade events, but what was a little weird for a Christmas parade is that they uniformly portrayed Old Testament figures, both heroes and villains. Goliath was there, brandishing a sword and a shield that looked like a giant pizza, and one of Sonneborn's balloons that had formerly represented a lamb (as in Mary's little one) received a bronze-colored paint job and was promoted as the "golden calf" (a part of history few people would want to salute, at Christmas or any other time).

In 1968, the balloon parade was another Saturday morning affair, this time taking place almost two weeks before Thanksgiving. Again loosely

After Thanksgiving, Downtown Birmingham Becomes

Your Holiday City

THREE FESTIVE DAYS HERALD THE MOST EXCITING CHRISTMAS SEASON EVER!

FRIDAY NIGHT at 6 P.M.

Christmas Lights Go On in Downtown Birmingham. You'll see these colorful decorations on every corner, sparkling across the streets, transforming the city into a Holiday Fairyland!

SATURDAY—9:30 A.M.

A Big Balloon Parade Right Through the City Streets! Don't miss it! It is even bigger and better than last year's! These are all new balloons, you've never seen before. Floating higher than ever, Birmingham's pretty Princesses, one from each of the high schools, will ride in the Christmas Parade! It will be easier to see the parade this year! The parade route will be extended from Twenty-First Street to Eighteenth Street. Come early to get the best place!

MONDAY NIGHT at 6 P.M.

100,000 LIGHTS WILL BE TURNED ON IN WOODROW WILSON PARK.

A giant Christmas tree will glow from the lowest branch to the star at the top ... and tiny bulbs will sparkle from every other tree in the park! These lights will burn every night from Monday through Christmas. It's a sight that every one should see!

DOWNTOWN ACTION COMMITTEE

Left: The artwork for this 1967 ad heralding the downtown holiday activities may have been produced before someone made the decision to hold the balloon parade on a Saturday morning rather than at night.

Below: There was no doubt about it: some of the balloons in the annual parade were downright homely. In 1967, the theme seems to have been built around Old Testament heroes and villains alike. Here we have one of each: Joseph (in his multicolored coat) is pursued closely by the infamous golden calf.

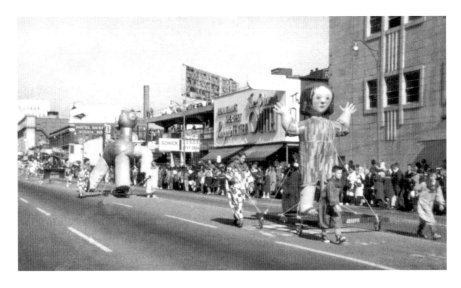

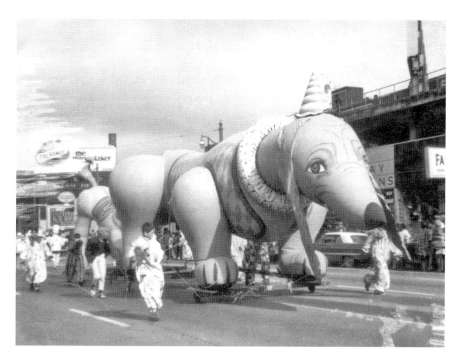

Pip the Dog was one of the featured stars of the 1968 balloon parade, which had a circus theme. Also in the parade that year was an unlicensed figure of Doctor Dolittle, star of the movie musical bearing his name.

following a theme, the city rented anything Sonneborn offered that looked even vaguely connected with the circus, including a procession of elephants, a rotund clown sure to give nightmares to those with phobias, a lion, a leopard, a circus pony and a number of others.

The 1969 parade went back to being held at night. In the past, the balloon characters had been more or less generic in nature or at least represented public domain literary and fairy tale characters. Nowhere to be found were official, licensed, copyrighted cartoon characters of the type Macy's dealt with. For 1969, there were still no official licensed characters, but that didn't preclude knockoffs from making the scene. With Charles Schulz's *Peanuts* comic strip at the height of its popularity, Giant Balloon Parades Inc. decided to risk the wrath of the Red Baron and United Features Syndicate and produce its own phony baloney *Peanuts* character figures. Just to be sure no one mistook them for the real things, each monstrosity had a mutilated name painted on its rolling wooden platform. You funny paper readers out there surely remember good ol' "Charlie Braun" and his white dog "Snooper," right? What about his

67

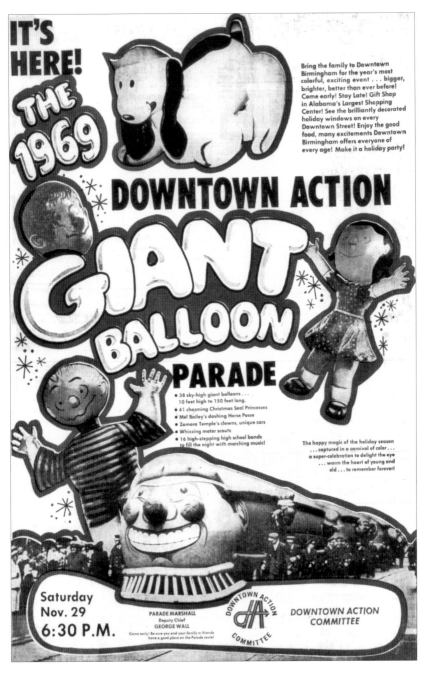

The last of the downtown balloon parades was held in 1969, once again at night. Even in the dark, these knockoffs of Charles Schulz's beloved *Peanuts* comic strip characters fooled no one into mistaking them for officially licensed items.

friends "Linnus" and "Licy"? There they all were in Birmingham in November 1969, big as life and three times as unnatural.

(Bill Smith reports that within a year or two, and after Birmingham was no longer staging these events, Sonneborn's company tried the same stunt with bootleg balloons representing the *Sesame Street* Muppets, and retaliation from the Children's Television Workshop and Jim Henson was swift and vicious.)

One characteristic of Sonneborn's Giant Balloon Parades, Inc., was that past balloons were often converted into new forms as need dictated. The bizarre "Charlie Braun," for example, had the same body as biblical hero Joseph (and his many-colored garment) from the 1967 parade. Villainous Captain Hook made enough trouble for Peter Pan as he was, so there seemed to be no good reason for Sonneborn's version to be posed flexing his biceps—until one studies older photos and realizes that Hook's torso and arms formerly belonged to Superman.

No formal explanation was given for why the balloon parades ceased after 1969. As we have seen, the temporary halting of the Living Christmas Tree ceremony made news, but when 1970 rolled around, there was no mourning the loss of a tradition as far as the parade was concerned. (In fact, the Sonneborn balloons were rented by the City of Anniston that year, and it merely looked like Birmingham's procession had made a trip east.)

As we shall see in our next chapter, during the 1970s the concept of a parade primarily moved indoors, to the several shopping malls that had so rapidly replaced downtown as the places for Christmas shopping. There were, however, a few leftover attempts to bring back the tradition, but they are almost pitiful to acknowledge.

In 1980 and 1981, the Fourth Avenue Merchants Association staged its own parade with marching bands and floats, ending with a tree-lighting ceremony at Kelly Ingram Park. The public's response to this event can, unfortunately, be judged by the two opening sentences of the *Birmingham News*'s report the next day: "What if there was a parade and nobody came? That's exactly what happened in downtown Birmingham Saturday." The article went on to say that only a few small groups of people braved the cold to cluster along Fourth and Fifth Avenues to see the seven floats, including one with Levon McGhee doing his best Santa impersonation.

Apparently undaunted, or at least unwilling to admit the battle to attract downtown shoppers was well and truly lost, in early December 1982 the DAC and its younger compatriot, Operation New Birmingham, announced they would try yet another parade that would begin at Woodrow Wilson

Park, proceed south on Nineteenth Street, turn east on Third Avenue, south on Twentieth Street, west on Second Avenue and then back north on Nineteenth to its starting point. No one dared mention that this route was going to take it past the hulking skeletons of so many veteran downtown businesses that had closed—at least Pizitz was still hanging on for the time being. It was promoted as "the first of its kind in downtown Birmingham," ignoring several decades of history.

And speaking of ignoring history, around 1986, the chamber of commerce and DAC even toyed with the idea of reviving the balloon parade concept. The problem was that, when it was pointed out to them that downtown had already had that type of parade back in the 1960s, it came as a total surprise to those who thought they had come up with something new. Needless to say, the big balloons did not return.

Downtown has certainly had a resurgence as a residential area since then, but if anyone has seriously considered making a Christmas parade a new annual affair, it has not happened as of this writing. However, there was a time when it seemed people would never return to the downtown streets to shop and attend shows at the Alabama Theatre, so perhaps nothing is impossible. Keep those majorette uniforms handy and make sure there is always a fire truck available for old Santa; he just might need it for comin' to town once more.

Chapter Four
DECK THE MALLS

The slow spread of retail business (and, for our point here, their associated Christmas celebrations) from downtown into the suburbs is generally considered a post–World War II phenomenon. Indeed it was, but Birmingham's first inkling that things were about to change actually took place a few months before the United States entered that conflict.

In April 1941, development company Shepherd-Sloss announced that it would be building the first phase of a giant new shopping complex near the Alabama State Fairgrounds. The new shopping center would be known as Five Points West, a name that was not even thoroughly explained when the announcement was made. Other than specifying that the shopping center would sit where the routes to Ensley, Fairfield, Bessemer and Birmingham converged, nothing else was said as to what the "five points" represented. (The name was undoubtedly inspired by Birmingham's Five Points South neighborhood, where five streets crossed each other like spokes in a wheel.)

A. Page Sloss of Shepherd-Sloss said a lot in a few words:

> The 24-acre site we have selected for this shopping center is about halfway between the downtown retail district and Ensley, Fairfield and Westfield, and population studies show it is the central point of a trade area of 150,000 people, most of whom derive their livelihood from the huge operations of the large industrial companies in the western area.

When WAPI Radio held a promotion in the parking lot of the sprawling Five Points West Shopping City in the early 1960s, the resulting panoramic photograph captured not only the many storefronts but also the rather understated Christmas decorations on the light poles.

In 1941, no one could have imagined that the reasoning behind that site selection would eventually cause more problems than it solved. When Five Points West Shopping City opened in the fall of that year, it was treated as an event of major retail importance.

Most of the stores that would long come to be associated with Five Points West arrived in the 1950s and into the early 1960s. Five-and-ten rivals F.W. Woolworth and W.T. Grant were placed cheek by jowl and managed to survive without killing each other until the chain of Grant's stores went out of business in 1975. The Kroger supermarket was another longtime tenant, as was JCPenney, one of the few major national chains that somehow avoided having a downtown Birmingham location. As the decades passed, even the management of the shopping center failed to keep track of just how long it had been there. For example, in the fall of 1963, the complex celebrated its twenty-third anniversary, as if it had been opened in 1940. But in the fall of 1973, it observed its thirty-second anniversary, which was more correct. The public seemed not to care either way, as long as it meant big sales promotions in all the resident stores.

All of this was leading up to the point that Five Points West does not seem to have done much that was out of the ordinary when it comes to its Christmas celebrations. There is a terrific panoramic nighttime photo of nearly the entire shopping strip during a WAPI Radio promotion in the early 1960s, but the holiday decorations mounted to the parking lot light

poles are certainly nothing to compare with what was being done downtown at the same time.

As we will learn a few pages from now, by the 1960s it was obvious that enclosed malls were going to (at least temporarily) supplant open-air shopping centers as the preferred venues for customers. Five Points West was purchased by Alabama Farm Bureau Insurance in 1966, and the following spring, the company announced that an enclosed mall would become part of the complex. Demolishing some apartment buildings that occupied ten and a half acres behind the main Five Points West strip gave enough room for a major addition, and a mall was cut through the center of the strip to give access from the front. The main tenant in the new mall portion was a Pizitz branch, which opened in August 1968. Other businesses that established their presence in the new section were Book World, a cozy corner of the type rarely seen these days; the Sandwich Chef snack counter; Kinney Shoes (owned by Woolworth's); and the studios of WBUL Radio. In the large open area in front of Pizitz's main entrance was a giant fountain that would be pressed into service as a major Christmas decoration display each year.

At least the mall portion of Five Points West gave the complex a chance to employ the "single mall Santa" concept that was rapidly replacing the time-honored—but undeniably confusing to kids—idea of each store having its own resident Kringle on duty. In the 1970s, Five Points West belatedly jumped on the Breakfast with Santa toy wagon that had been so successful downtown, but fittingly for the scaled-down size of the operation, it was held for one day only, the Friday morning after Thanksgiving. The ads did not specify any particular location for the meal except "in the mall," so presumably it was not connected with any specific area restaurant. The

Shopping centers and later malls got away from the concept of every store having its own Santa Claus; instead, the merchants banded together to have a single Kringle for the entire complex.

Krispy Kreme Doughnuts outlet in the Five Points parking lot did get in a plug for supplying goodies, which would have been enough to lure in the moms and dads even without their offspring in tow.

As the first article announcing the construction of the "shopping city" had mentioned, Five Points West's fortunes were, for good or bad, tied to its location near some of Birmingham's busiest industrial sites. That turned out to be more bad than good as the 1980s arrived; with the gradual closure of the steel mills, Five Points' reputation took a hit. Being adjacent to the state fairgrounds and the Kiddieland amusement park

helped, but those landmarks also faded away, leaving Five Points West to fend for itself. The shopping center is still there, but with none of the old-time tenants, and the 1968 mall addition was demolished around 2006, after crumbling into disrepair.

Extremely similar to Five Points West in many ways was Roebuck Plaza Shopping Center, which opened on U.S. Highway 11, about as far east as one could go and still be within the Birmingham metro area. Roebuck's advent in March 1957 was treated as a major newsworthy event, but the ads give the impression that it was basically a mirror image of Five Points West, with even many of the same stores and other businesses as tenants. In March 1961, Roebuck even got its own Pizitz branch store, beating Five Points West by seven years.

Unlike its western area counterpart, Roebuck never succumbed to the temptation to build a mall. Its Christmas activities remained outdoors; in 1961, Santa Claus could be found ensconced in an "igloo" that looked more like an army surplus pup tent of some sort. In later years, Santa made a more spectacular arrival at Roebuck on the day after Thanksgiving, parachuting into the western end of the parking lot. "Plan to join the parade back to Santa's throne on the east side in front of Sikes-Bratton Shoes," the ads elaborated.

Perhaps Roebuck eventually employed a St. Nick who suffered from acrophobia, because by 1977, he was remaining firmly earthbound. That year's ads gave the new approach to an old tradition:

> *Santa's coming to Roebuck in a blaze of glory this year, aboard his very own fire truck! With lights flashing and the sirens wide open, he'll be heading up our Santa parade! The Banks High School band will be there, along with the Banks cheerleaders who'll be Santa's helpers. Get all fired up, bring the kids, and let's welcome Santa in a big way!*

Five Points West and Roebuck Shopping City turned out to be merely the opening act for what would become one of the most beloved shopping destinations in the Birmingham metroplex: Eastwood Mall. Even though the newspaper coverage of its debut provided plenty of hype that was more than ripe, there was no exaggeration when the claim was made that it was a sight "never before seen in the Deep South."

That was true enough, since the relatively new concept of an enclosed shopping mall was completely foreign to the southern states up until Eastwood rode into town. In fact, among the many, many articles exploring

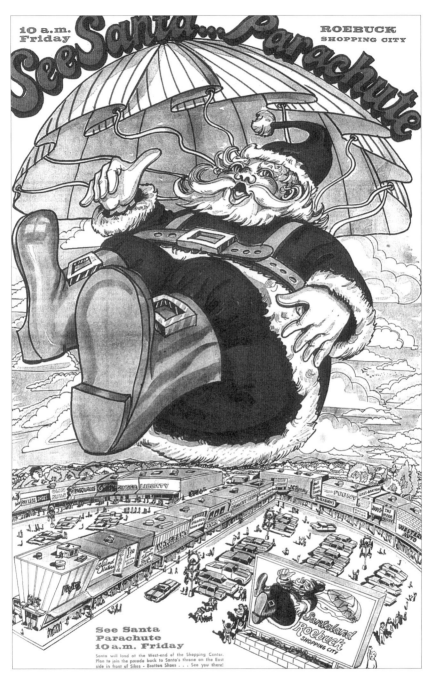

Roebuck Shopping City was to the eastern part of town what Five Points West was to the other end. Santa Claus made his grand entrance on the day after Thanksgiving by parachuting his way into the parking lot.

the new destination from all angles was one that demonstrates just how unfamiliar people were with this new form of retail. Under the heading "Just What Is a Mall?" came this explanation:

> *Almost everybody's talking about—and excited about—the grand opening of the fabulous Eastwood Mall at 10 a.m. tomorrow. But do you know what a mall is?*
>
> *Webster defines a mall as: "Originally, a place for playing pall-mall. Hence, a shaded walk. Later a fashionable promenade made therefrom, in St. James's Park, London; also a similar fashionable promenade elsewhere."*
>
> *And take it from almost everyone who sees Eastwood Mall, "it's the most fashionable merchandise showplace in the Southeast." Just imagine eight acres air-conditioned under one roof.*

The grand opening of Eastwood Mall took place on August 25, 1960, so the place was barely three months old when its first Christmas season kicked into high gear during Thanksgiving weekend. The bailiwick where Santa Claus hung out that season was promoted as the White Christmas Fantasy Land, described as "a delightful surprise for the children of all ages," with a snow white igloo and golden throne for Mr. Kringle. Many years later, former mall employee Joni Hicks recalled that first Christmas campaign as somewhat of a floppola, with Santa dressed in an all-white suit, sitting next to an all-white Christmas tree.

Within a couple of years, Eastwood had found what would be its Christmas kickoff tradition into the late 1970s. Not content with simply walking into the picture, on the day after Thanksgiving, Santa would be flown onto Eastwood Mall property in his own helicopter. Once they had found a good thing, the folks at Eastwood knew not to tinker with it; the same newspaper ad announcing Santa's airborne arrival ran for years, with only minor updating in its later appearances.

Since the big event tended to stay pretty much the same from year to year, let's pull out the newspaper coverage from 1968, about halfway through the tradition's long run, and see just how it was all going to play out:

> *The helicopter bringing Santa to the mall will land at noon near the center of the south parking lot, where thousands of friends will be on hand to welcome him. The jolly old fellow will be escorted by two of his pretty helpers to his special place in the mall.*

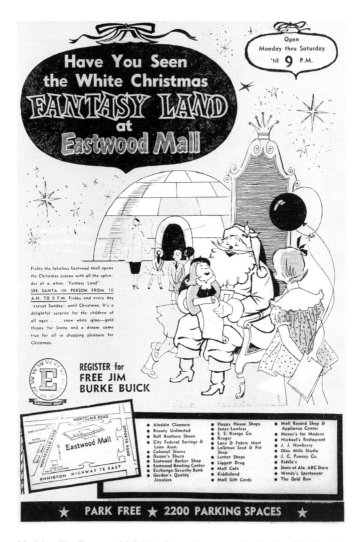

Nothing like Eastwood Mall had ever been seen in the South before its August 1960 opening. For the mall's first Christmas season, there was a not-so-popular attempt to have Santa and his entire surroundings all in white.

So many of his young friends have indicated they will be at Eastwood Mall on Friday to greet Santa Claus that he has made plans to stay until midnight to talk to each boy and girl who comes to welcome him.

Wow, after twelve hours of holding kids on his lap, it's a wonder Santa even had a "ho ho ho" left in him, but that was the price for representing what

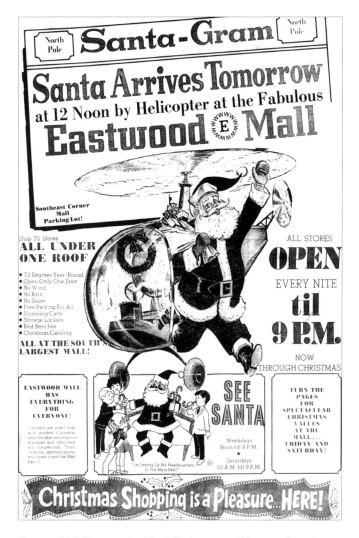

Eastwood Mall's most cherished Christmas tradition was Santa's arrival by helicopter. Versions of this same newspaper ad ran throughout the 1960s, and Santa continued to land in the parking lot well into the 1970s.

remained the largest mall in the Southeast for quite some time. The same article went into unusual detail in describing the setting for St. Nick's temporary home away from home:

> *Encircling the mirrored pillar in the west end of the mall will be a platform for Santa's throne in a forest of fairy trees twinkling with colored lights. It*

The original caption on this publicity photograph reads: "Santa started his saving program early for Christmas 1976 last week when he opened an account at the Eastwood Mall office of City Federal Savings and Loan Association. Helping Santa with his new account were, from left, Sharon Cook, Becky Wesson and Debbie Shoults."

will be reached by a gently slanting ramp with no difficult steps for chubby little legs.

Although Santa's is a special place, the entire length and width of Eastwood Mall is agleam with holiday decorations. Gold and silver garlands and stars sparkle overhead on either side of the walks, and all along the way are exciting and inviting displays of a million things it would be great to get or give for Christmas.

As if it were not already becoming clear, people by this time should have been getting the idea that malls such as Eastwood were rapidly evolving into more comfortable indoor versions of what shoppers had been experiencing downtown in the past. Yes, there were overhead decorations, window displays and the jolly old man in the red suit, but there was no automobile traffic, no icy winds blowing between the tall buildings and no need to struggle for blocks to get from one store to the next. This, it seemed, was the perfect way to do one's Christmas shopping early, late or right on time.

During the 1970s, as downtown's Christmas traditions were shriveling like a pumpkin left on the porch a month after Halloween, Eastwood Mall's celebration continued to grow. In 1974, Eastwood enlisted the help of the Workshop, Inc., a Goodwill Industries–type organization that employed the physically and mentally disabled. This group fashioned an entirely new set of decorations for the mall, most notably the signature "Santa Mice" dolls that proliferated. There was also an animated "Sleeping Santa" that appeared to breathe. (Not only did it seem superfluous to have a mechanical Santa when the live one was sitting right there, but also back downtown, Pizitz was using a very similar figure in the Enchanted Forest.)

By the following Christmas season, Eastwood had become a branch of Santa's workshop (most likely again thanks to the Workshop). For 1975, the ads promised, "Bring the children and Santa will let them help put the finishing touches on the toys he's making. And, if you like, capture this precious moment forever by letting Creative Photographers get pictures of your child with Santa and his workbench."

And there we see at least the beginning of a side of Christmas that would become more and more common over the next several years—namely, that the vast majority of the mall Santas are not hired or employed by their respective shopping outlets. The malls hire a photography company to handle the Santa photograph concession, and those entities are responsible for bringing in their favorite Santas from the far corners of the country to spend a holiday in their host city. There would be, and still are, exceptions to the rule, but the fact that Creative Photographers was mentioned so prominently in that particular ad shows that the day of remote-controlled, photo-controlled Santas was certainly looming large.

No matter who was issuing his paycheck, 1977 was the last year for Eastwood's Santa to arrive by helicopter. That year, he was escorted by WBMG-TV kids' show host Neal "Sergeant Jack" Miller, whose weekday afternoon show had ended in September 1976. He was still being seen on weekends, however, and obviously could still draw an audience. For 1978, Santa traveled back through time and arrived at Eastwood in a horse-drawn buggy. ("There'll be a lot of whoaing and ho-ho-hoing going on," the ads chortled.) And in 1979, Santa was all but upstaged by Eastwood's newest Christmas character, Rodney the Elf, who was on hand "giving out candy canes and spreading lots of Christmas joy."

Rodney couldn't hold a Christmas candle to his bewhiskered boss, though, and in the late 1970s and early 1980s, there was quite a lot of newspaper coverage of the genuine jolly old gent under the fake beard. It was Jesse

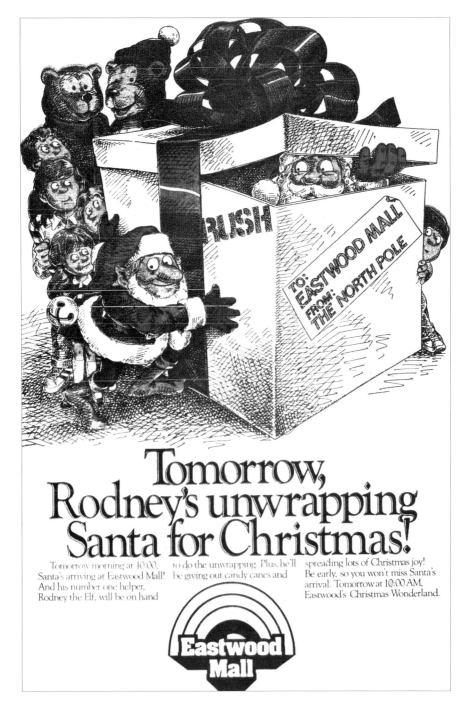

Rodney the Elf, one of Santa's myriad helpers, was responsible for unwrapping Eastwood Mall's celebration for the 1979 holiday season.

Gresham, in his early seventies at the time, who spent five hours a day, six days a week, on a sugarplum throne with kids perched on his knee. "If I didn't love the spirit of Christmas, I wouldn't be sitting here," he told a reporter. "I'd be with my grandchildren. I do it for the rewards you receive, the labor of love. Being Santa is its own reward, like virtue. If they stopped my pay this hour, I'd still be here. It makes you feel like somebody, and it lights you up like a Christmas tree."

Santa, aka Gresham, elaborated on how his job required staying up to date on what the kids were going to be asking for, prompting a litany of circa 1980 hot toys: "When they ask for a Merlin, an electronic game, I know exactly what they're talking about. Most of the girls are asking for Barbie doll houses, and Strawberry Shortcake and Apple Dumplin' dolls. The boys want race tracks, Stretch Armstrong dolls and Star Wars people."

(OK, kids are still asking for those toys for Christmas, but the kids are now forty years old and wanting them as valuable pop culture collectibles. During the 2014 Christmas season, Honda produced a series of automotive commercials using many of those same toys to try to tap into potential customers' nostalgia reserves.)

As we shall soon see, after having the mall market virtually to itself for nearly a decade, in the 1970s and 1980s Eastwood found itself being overshadowed by larger and fancier malls spread across the metro Birmingham area. Eastwood began to look like a dinosaur whose extinction date was long past. Slowly, its tenants began to move elsewhere, until by 2004, the interior of the mall had been closed off. Several businesses with outdoor entrances managed to hang on until the mall owners, Lehman Brothers, made a deal with retail behemoth Walmart to sell the property. Demolition began in the summer of 2006 to make way for the 200,000-square-foot Walmart Supercenter and an adjacent shopping center (not a mall) with up to twenty tenants.

Naturally, the closing and destruction of Eastwood Mall prompted an outpouring of nostalgic memories from its former customers, and many of those were published in newspapers around the time of Eastwood's demise. Of course, the Christmas celebrations played a large role in those memories, with people recalling details ranging from the "all-white Christmas" debacle to Santa's annual helicopter flight.

(As a bit of trivia, one of the last surviving stores inside Eastwood Mall was the Party City establishment. It relocated to the shopping center built to accompany Walmart, making it the solitary business to operate in both the mall and the new complex.)

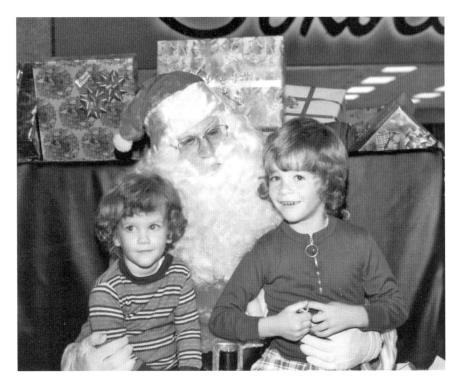

Western Hills Mall gave Santa a place of honor in the large open area in front of Sokol's clothing store in 1974. *Dennis Campbell collection.*

Considering what a popular destination Eastwood Mall was, it seems rather surprising that it took almost a decade before any additional malls snaked their way into the Birmingham area. West Lake Mall, on U.S. 11 in Bessemer, opened in October 1969, and Western Hills Mall, only a few miles north on the same highway on the border between Fairfield and Midfield, came to town in February 1970. Of the two, Western Hills was the larger and more elaborate, so it quite naturally played a bigger role when it was time for the Christmas season to make its annual appearance.

Eastwood Mall had been built so early in the mall concept's development that, until years after its opening, it lacked what would become the tradition of having a large "anchor" store at each end. Western Hills, on the other hand, fell firmly into that format, anchored by Loveman's at one end and JCPenney (which was then going through a phase when it was known simply as Penney's) at the other. In between the two stretched a corridor with all the usual types of mall businesses: clothing-oriented Sokol's and Eve's Leaves;

shoe stores; chain stores, such as Woolworth's; and eateries, including a Britling Cafeteria and a Baskin-Robbins ice cream shop.

From its first Christmas season, Western Hills Mall eagerly searched for ways to distinguish itself from the many other Birmingham businesses that had had years, if not decades, to build their own traditions. The longest lasting of those early ideas was the Singing Christmas Tree. This was not an animated figure like the Talking Christmas Tree in Pizitz's downtown Enchanted Forest, but a series of risers that was sturdy enough to support the members of assorted local choirs (both adults and children). Each night, a different set of carolers would be booked to perform their live musical selections, giving the whole mall a more unique sound than piped-in Christmas songs would have provided.

Santa did not go for anything outlandish when it came time to arrive at Western Hills, sticking to the traditional old fire engine for his transportation. On Saturday mornings between

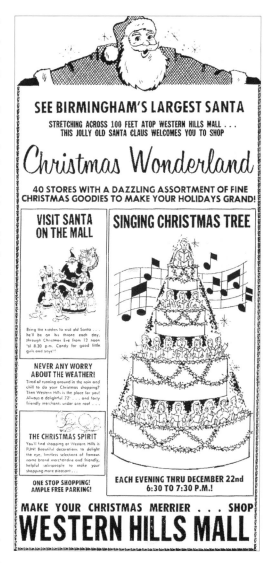

For Christmas 1972, Western Hills Mall made a special effort to advertise its "Birmingham's Largest Santa," an enormous decoration that stretched more than one hundred feet from mitten to mitten across the Loveman's end of the mall.

Thanksgiving and Christmas, Mrs. Claus would come down from the North Pole to join him for a story hour. In 1972, a secondary Santa made himself at home at Western Hills. Billed as "Birmingham's Largest Santa," the cutout

figure with outstretched arms spanned one hundred feet across the mall's exterior roofline.

By 1974, there were so many Christmas activities going on that the newspaper ads could not go into much detail about any of them. One such blurb gave a cryptic description:

> *Photograph your child with the Animal Fair characters: Leo the Lion, Bengie the Tiger, Smiley the Mouse, Great George the Dog and Henry the Dog. Visit Santa and have your picture taken in his big new sleigh. Ride the Christmas merry-go-round, see the Singing Christmas Tree, and have your name put in headlines in Santa's Western Hills Mall Gazette!*

Regarding the costumed characters from Animal Fair, a popular manufacturer of plush toys and hand puppets, we might make one observational aside. At the same time that these friendly figures were greeting kids at the mall, one of Animal Fair's Smiley the Mouse puppets, renamed Sneezer and operated by the capable hands of puppeteer Ted Lowry, was making daily appearances on WBMG-TV's *Sergeant Jack Show*. Did the kids who had their photographs taken with Smiley notice the resemblance?

WBMG-TV is also the source for another part of what we know about Western Hills from a few years later. As we shall see again in chapter five, surviving Birmingham TV footage (especially commercials) prior to the 1980s is rare. However, one of only a handful of accidentally preserved spots is a 1977 Western Hills Mall commercial that aired on, and was presumably produced by, WBMG. In only thirty seconds, it offers some tantalizing glimpses into a typical mall Christmas of the time.

The first fifteen seconds are devoted to Sokol's clothing store and what was considered fashionable in 1977. There were likely other versions of the same commercial in which other mall tenants got their own fifteen seconds because after the Sokol's plug there is a rather abrupt edit to the portion promoting Western Hills as a Christmas shopping destination. Using a combination of film and videotape, it shows an ice skater pirouetting on a rink in front of the Gateway Books and Kinney Shoes stores and a rather thin Santa Claus presenting a wrapped gift to an attractive helper whose blond hair is considerably longer than her miniature mini-skirt. (Mrs. Claus must have been busy with her story hour while Santa was filming that spot, ho ho ho.) As the announcer mentions "the little people from storybook land," we see some rudimentary animated figures of the Three Little Pigs and one-third of the Three Bears, much along the lines of the scenes in the

Birmingham's newest mall, Brookwood Village, opened in time for the 1974 Christmas season. It studiously had avoided even referring to itself as a mall and emphasized the New York origins of its initial Christmas decorations.

Enchanted Forest. In all, those thirty seconds are like taking a time machine back to a much different era.

Just as with Five Points West, Western Hills Mall suffered shrinking pains as the nearby steel mills either closed or greatly reduced their output. During the 1980s and 1990s, the mall continued to slide until at one point there were no remaining chain stores left in its mix.

The demographics changed as well. Steve Pennington, who had been hiring out as a Santa since the early 1980s, recalls that during either the 1999 or 2000 Christmas season, he became the "last white Santa" to be employed at Western Hills. At the same time, the mall also had an African American Santa, but contrary to what one might think considering Birmingham's reputation, the two Santas did not appear together with a separate but equal waiting line for each. No, Pennington and the alternate Claus would trade shifts, until it became obvious that Pennington's services would no longer be necessary. We shall encounter him again later in this chapter.

One of the new class of more upscale malls that had appeared during the 1970s was Brookwood Village, situated near the hospital of the same name and the Samford University campus. Brookwood Village's first Christmas season was 1974, and the mall quickly proved that it was not going to be the same as Eastwood, Western Hills or any of the others. Its Thanksgiving Day ad was headlined "At Brookwood Village, even our Christmas tree has a New York designer." The ad copy elaborated:

> *Because we hired designer Edward Schnittker of New York City to give our tree a new Christmas look, to match the new Christmas look our center is giving Birmingham.*
>
> *So bring your family to Brookwood Village, between 280 and 31-South, and see what Santa looks like. And what we think a Christmas tree ought to look like. And if you like some of the ideas, feel free to use them in decorating your own tree. Then you can tell all your friends that your tree has a New York designer too.*

You might have even detected a subtle change in that the word "mall" was not used in the above blurb, in favor of the term "center." Under either word, Brookwood Village quickly established its own Christmas traditions. Beginning in the late 1970s, the mall—er, center—eschewed the traditional "Santa's throne" and enshrined the merry old soul in his own Fantasy Castle, an elaborate setting surrounded by the now-traditional animated figures.

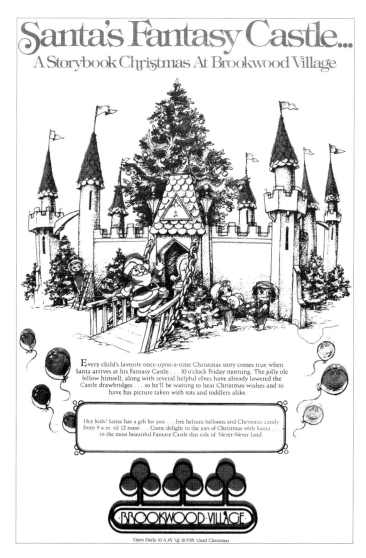

By 1979, Brookwood Village's Santa was enthroned in his own "Fantasy Castle." In later years, the mall would become noted for its annual Singing Santa, who crooned tunes in addition to making lists and checking them twice.

Malls, shopping centers and places such as Brookwood Village that preferred to be called neither had gradually been pushing the kickoff of the Christmas season earlier and earlier. Brookwood was something of a holdout when it came to Santa's arrival. By 1981, most of the others were welcoming Kris Kringle on the Saturday before Thanksgiving. Brookwood

stuck to its popguns, though, reserving the day after Thanksgiving for that big event. So as not to be completely left out, Brookwood turned on the lights in the Fantasy Castle on the Friday before Thanksgiving, even though its chief inhabitant was still at the North Pole. In his stead, the Alabama Ballet sent dancers from its annual production of *The Nutcracker* to take care of the entertainment until after the day of the turkey was over.

During that 1981 Christmas season, Santa appeared at Brookwood through the combined talents of Ralph Vaughn and Elven Austin, a retired steelworker. A slightly later Santa at Brookwood was radio and TV personality Ward MacIntrye. Twenty years earlier, MacIntyre had been WBRC-TV's much-beloved incarnation of Bozo the Clown, so he knew his way around conversing with youngsters. His son Gordon has certain comical memories of dear old Dad's tenure in the red suit:

> *I distinctly remember that when he went on break, he would go straight to his Pall Mall cigarettes. Watching Santa puffing away was quite a sight. My two daughters were very small and would sit in his lap, never knowing it was Granddaddy. I'm sure it was curious to them that he knew their names. And probably curious to them that Santa smelled like the same cigarettes that Granddaddy smoked! They think that's hilarious now.*

Regardless of who was playing Santa, Elven Austin perhaps summed it up best: "It's only for a few weeks, but when you put that suit on, you want to wear it forever. When else can you be Santa Claus?"

No matter how rewarding the job was, the fact remained that generic Santa Clauses were a dime a holiday dozen (or maybe they were a nickel a Nicholas). In the 1990s, Brookwood began distinguishing itself as home of the "Singing Santa," who not only held kids on his lap but also performed holiday songs and carols. The aforementioned Steve Pennington, who began serving as Brookwood's Singing Santa in the 2010s, recalls that the mall's first musical old elf was imported from California by the photography company that had the Brookwood concession. Perhaps the longest-serving Singing Santa was Bill Veazey, who faithfully performed his ditty duties until his death at age seventy-five during the 2012 Christmas season. Afterward, others (such as Pennington) took over, and the tradition has been maintained.

Cater-corner across U.S. Highway 78 from Eastwood Mall, Century Plaza opened during the summer of 1975. Like Brookwood, it fastidiously avoided calling itself a mall, and when its first Christmas season arrived,

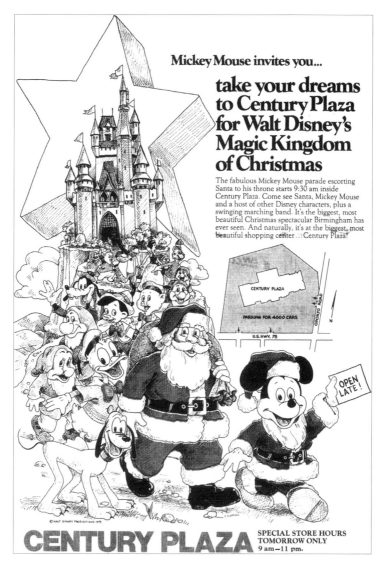

Mickey Mouse invites you...

take your dreams to Century Plaza for Walt Disney's Magic Kingdom of Christmas

The fabulous Mickey Mouse parade escorting Santa to his throne starts 9:30 am inside Century Plaza. Come see Santa, Mickey Mouse and a host of other Disney characters, plus a swinging marching band. It's the biggest, most beautiful Christmas spectacular Birmingham has ever seen. And naturally, it's at the biggest, most beautiful shopping center...Century Plaza!

CENTURY PLAZA

PARKING FOR 4000 CARS

OXMOOR ROAD

U.S. HWY. 78

OPEN LATE!

© WALT DISNEY PRODUCTIONS 1975

CENTURY PLAZA SPECIAL STORE HOURS TOMORROW ONLY 9 am–11 pm.

From its first Christmas season in 1975, Century Plaza allied itself with the Wonderful World of Disney, presenting an ever-growing display known as the Magic Kingdom of Christmas. Mickey, Donald and all their friends from Fantasyland set up shop in Birmingham each year.

Century Plaza took on a promotion that was truly unique among its Birmingham brethren.

The Disney studios had been marketing a Christmas display known as Walt Disney's Magic Kingdom of Christmas in other parts of the country;

its name suggests that it might have originated as part of the promotion for the opening of Walt Disney World's Magic Kingdom in Orlando in 1971. In fact, a few animated Disney characters (figures, not animated cartoons) had decorated the windows at the downtown Loveman's store that same year. When Century Plaza debuted the Magic Kingdom of Christmas in 1975, the setting included animated tableaux from a number of Disney's greatest hits, including Snow White, the Three Little Pigs and, of course, the Fab Five of Mickey, Minnie, Donald, Pluto and Goofy. With all the stars from Anaheim, Orlando and Burbank on the premises, it might have been a bit difficult to find Santa situated in the middle of them all.

Century Plaza made it a tradition to open the Magic Kingdom with a parade through the mall, complete with a full cast of costumed Disney characters, at 9:30 a.m. on the Saturday after Thanksgiving. But unlike most such holiday kickoff events, it was not a one-time offering. A few days later, the newspaper ads chirped, "When we had the Mickey Mouse Parade at Century Plaza last Saturday, so many people were there that a lot of them didn't get to see our hero! So by popular demand, Mickey will be back again at 10 a.m. this Saturday. Come one, come all! And if you can't make it this Saturday, he'll parade again December 13 and 20, same time, same place."

And so, with four Christmas parades during one season, Century Plaza set a record the other malls had not even considered. In future years, multiple parades would continue. By 1981, Mickey's place as leader of the club had temporarily been usurped by ursine Winnie-the-Pooh, perhaps because Pooh had been working as a representative for Sears, one of Century Plaza's anchor stores, for many years. The Magic Kingdom continued to appear each Christmas well into the 1980s, and even some new scenes were added to represent the studio's big holiday hit of 1983, *Mickey's Christmas Carol*.

(Speaking of anchor stores, Century Plaza also had Rich's, a branch of the legendary Atlanta hometown department store. Rich's brought in its own established Christmas traditions, including Richie Bear, a white teddy bear that was the store's official holiday season mascot.)

When Mickey and the gang finally left Century Plaza, it was to make room for another bear that was bigger than Pooh's and Richie's whole families put together. Jingles the Bear was an enormous remote-controlled puppet that towered over the people and decorations in Century Plaza's center court, delighting some kids and frightening the sugarplums out of others. Just as with Pizitz's Talking Christmas Tree, Jingles' operator provided the bear's voice and controlled the movements of the cheerful teddy's head, mouth and eyes. Unlike Pizitz's tree, though, the voice of Jingles was not cooped up inside

the figure's carcass. Unnoticed by everyone, the puppeteer was stationed among the crowds with a clear view of whatever youngsters happened to be conversing with their giant friend. Remote control technology enabled the bear's various moving parts to work.

(Reinforcing the connection with Pizitz, the scenery surrounding Jingles made use of some of the cast-off animated figures that had formerly enlivened the Enchanted Forest. Some of them were nearing thirty years old, so this was truly their last public bow before being consigned to the trash heap or forgotten storage rooms.)

Just as its neighbor on the other side of U.S. 78, Eastwood Mall, fell into a decline, so eventually did Century Plaza. Most experts blamed its rapid fade on the fact that the exterior and interior of the mall remained basically unchanged (or, more correctly, non-updated), making it look increasingly like a time capsule of 1975 or the world's largest, emptiest fern bar. By the fall of 2008, only one specialty clothing shop remained in Century Plaza's cavernous interior, and all of the former anchor stores, except Sears, had long since fled. In February 2009, when Sears, too, announced it was picking up its Roebucks and quitting the scene, everyone knew that was the end. The interior parts of Century Plaza were closed on May 31 that year, and Sears held down its end for two more weeks to liquidate the contents.

Since that time, the abandoned Century Plaza has sat on its corner lot as various proposals for its use or demolition have been discussed. One mystery is whatever became of Jingles the Bear and her holiday cohorts. There are spotty reports that they still sit somewhere within the shuttered complex, slowly moldering away, but whether or not that is true, it seems obvious that neither they nor Disney's Magic Kingdom of Christmas will ever be making a return appearance on their former home turf.

Century Plaza was done in by a number of factors, but the biggest was that shoppers had simply moved on with their lives to a different type of experience. When the Riverchase Galleria opened just south of town in February 1986, it represented the very latest trends in indoor shopping. It was no small irony that the Galleria's developer, Jim Wilson and Associates, also owned both Eastwood Mall and Five Points West at the time. The new kid on the Wilson block was about to knock the blocks off its older relatives.

The Galleria's first Christmas season was ushered in on November 14, 1986, with what bore the appropriately pretentious name the "Grand Lighting Ceremony." Thousands of people crammed into the mall's interior to witness the initial illumination of the overhead lights and decorations and to marvel at the Galleria's most noticeable Christmas innovation.

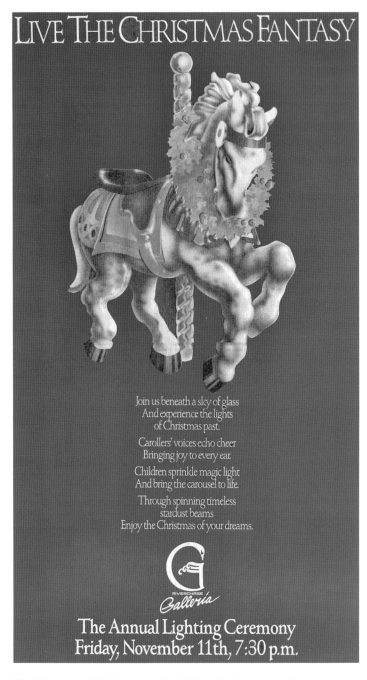

The Riverchase Galleria opened in 1986 as the largest (and last, to date) enclosed mall in the Birmingham metro area. Its annual lighting ceremony still attracts crowds by the thousands.

Many shoppers, overwhelmed by the Christmas season, might have felt that their heads were spinning, but the Galleria took that literally and installed a whirling twenty-four-unit carousel over what served as the central atrium's fountain the other eleven months of the year. A press release demonstrated that the Galleria was going to be no shrinking edelweiss when it came to the holidays:

> *Carolers, choirs, mimes, popcorn and Saint Nick combine with fashion, glamour, chocolate and holly wreaths to create a spirit of Christmas never before experienced in Birmingham, Alabama or the Southeast. Santa will arrive in style aboard his elegant swan sleigh and be available to hear your child's Christmas wishes.*

It was the carousel that became the true star of the holidays, however. In fact, it was so popular that eventually it was never dismantled after the Christmas season, but left in place to operate all year—a rare, but not unique, honor for a Christmas decoration. After the 2012 Yuletide season, the ride was given a thorough makeover that included repainting its bounding horses, frogs, tigers and other fauna and (belatedly?) removing its red-and-green fabric top—a remnant of its Christmas origins. Upon its reopening in August 2013, it was pointed out that the carousel now sat level with the floor rather than being perched on the long-unused fountain base it had originally been designed to cover.

While there seems to be no immediate danger of the Galleria meeting the same fate as Eastwood Mall and Century Plaza, shopping habits and preferences have indeed continued to change since its opening. At some point, enclosed malls began to fall out of favor, and people began to prefer open-air shopping centers of the type pioneered by Five Points West. No longer keen on walking for what seemed like miles down a mall's corridor, shoppers expressed a new interest in being able to park near their favorite store's exterior entrance, get in and get out.

Thus, in the fall of 1997 came Birmingham's newest contribution to this style, the Summit, hard by the side of overcrowded U.S. 280 as it crept southeast of town. By that time, the hoary four-letter word "mall" was truly a taboo term, and venues such as the Summit were referred to as "lifestyle centers." Of course, Christmas continued to be the biggest deal of the year even at these newfangled shopping outlets, and Santa and his helpers could be counted on to hang out at them just as he had at the malls before that and the downtown stores even before that. The Summit has barely been around

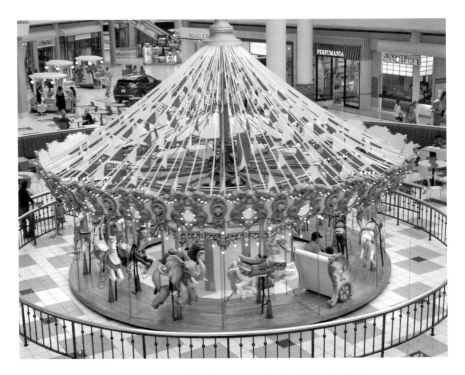

The Riverchase Galleria carousel originally appeared only during the Christmas season, twirling atop the base that served as the central atrium's fountain for the other eleven months of the year. However, it became so popular that the carousel now remains operational all year, and few people remember that it was once a Yuletide decoration.

long enough for one generation of youngsters to make their own Christmas memories there, but as sure as Rudolph has a flaming proboscis, in the coming years adults will look back on the Summit with the same wistful nostalgia that their parents and grandparents feel when they recall seeing Santa parachute onto a shopping center parking lot or parade through a mall with all his staff alongside.

Chapter Five
RAISINS FOR RUDOLPH

If a person really wants to separate the Whos from the Grinches when it comes to Birmingham Christmas traditions, there can be no greater gauge than to ask for opinions on when it is appropriate for 24/7 Christmas music to begin playing on the radio. That the question has to be asked at all is just another of those quirky things that has seemingly been around so long that it has become a tradition.

As we shall see later in this chapter, during the 1950s and 1960s, it was nothing unusual for Birmingham radio stations to schedule a full day of holiday programming on December 25. In fact, with the gradual erosion of feeds from the old radio networks, local stations were having to depend on themselves more and more to fill the broadcast day. Stations that relied on music and records to keep people listening between the commercials could usually be counted on to begin sprinkling some Christmas songs into the mix shortly after Thanksgiving. But as radio became more segmented, and each station's format more specialized, it sometimes became difficult to find any Christmas music. A Top 40 station could incorporate Dean Martin and Bing Crosby almost seamlessly but what about country music stations? Or those that dealt only in hard rock? Nat King Cole might still have been roasting chestnuts on an open fire, but it was rare to hear him doing it between the latest Motown hits.

Thus, in the late 1970s, "easy listening" station WQEZ, at 96.5 on the FM dial, came up with what was then a novel concept. From noon on Christmas Eve until midnight on Christmas Day—thirty-six hours, in case you're

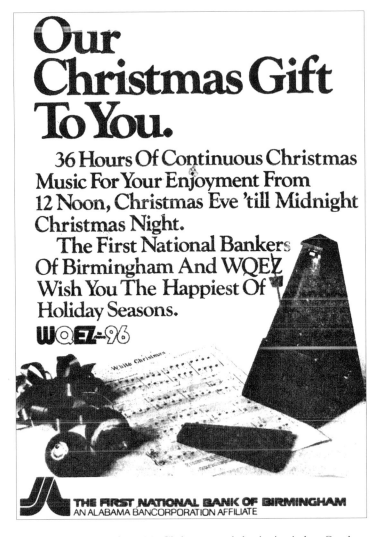

Whether you love having 24/7 Christmas music beginning in late October or hate it, you can thank WQEZ Radio (now known as "Magic 96.5") for beginning the tradition. This 1977 ad was promoting its thirty-six hours, which have now expanded into more than thirty-six days, of continuous Christmas music.

counting—the station would play nothing but Christmas music. In the early days, this marathon was sponsored by the First National Bank of Birmingham and promoted in ads with the slogan "Our Christmas Gift to You."

Now, what is it they say about gifts that keep on giving? Over the years, even as the station on 96.5 changed formats and names, the tradition of

continuous Christmas music remained unchanged. By the dawn of the twenty-first century, it was known as WMJJ ("Magic 96.5"), and its Christmas music season had grown longer. Now it began the week of Thanksgiving, providing at least a month of nothing but holiday cheer. But like a creature in a 1950s horror movie, it did not stop growing. With listeners clamoring for more, the station expanded its Christmas season further back into November. One year, the Christmas music actually began on Halloween, and Scrooges were aghast. As of the last season before this book went to press, the music began on October 25, or exactly two months before Christmas Day.

Before the emergence of stations playing nothing but Christmas music, songs from such performers as Bing Crosby and Gene Autry could be found mixed in among the regular playlists.

With the golden age of network radio drama, variety and comedy having only recently come to an end, stations were forced to come up with their own Christmas programming, as WAPI Radio did for this 1960 ad.

Obviously no broadcast station in its right mind would do this unless it meant major increases in revenue and ratings, so the standard joke is that before long we will be able to hear Bing dreaming of a white Christmas on July 4. Actually, WMJJ has also made an annual tradition of devoting at least one summer weekend—and sometimes more than one—to the same Christmas music combination that will enliven the genuine season once it arrives. As we said above, whether one anticipates or dreads this annual onslaught of merry music has a lot to say about one's attitude toward Christmas in general.

To travel back to a much earlier era and just pick an example at random, let's look at what powerhouse station WAPI did on Christmas Eve 1958, as the golden age of network radio was rapidly drawing to a close. The evening began at 6:45 p.m. with *Dave Campbell's Christmas Story*. With the talk show host's many years of playing Santa Claus, he no doubt had dozens of Christmas stories he could tell, but which particular one was the subject of this show was not specified. Beginning at 7:00 p.m. came a series of recorded shows that could have originated either in WAPI's library or from the NBC Radio network: *Christmas Around the World* with orchestra leader Fred Waring and the Pennsylvanians; *Dickens' Christmas Carol*, starring ex-Sherlock Basil Rathbone; *The Littlest Angel*, as told by Loretta Young; and *Around the Christmas Tree* with Bing Crosby and the Andrews Sisters.

At 8:30 p.m., local personalities took over once more, with WAPI radio and TV hosts Bette Lee and Sterling Brewer hosting *The Magic Night*, featuring the Henry Kimbrell trio. (Kimbrell was a longtime WAPI studio musician and is credited with composing the "Jack's Hamburgers for fifteen cents are so good, good, good" jingle.) At 8:45 p.m. came the *Life Line Christmas Show*, and at 10:30 and 11:00 p.m., respectively, were services from the Church of the Advent and St. Patrick's Cathedral. At midnight, just about the time the jolly fat man was sliding down chimneys, he could have listened to Tallulah Bankhead and Loretta Young (again) in *Treasure of Christmas*.

Many of the same shows could still be heard on WAPI two seasons later, filling up Christmas Day. At 8:30 a.m., Leland Childs hosted a *Christmas Sing-Along*, and from 6:00 to 6:45 p.m., *Christmas at WAPI* starred three jolly, happy souls: Jim Lucas, Ron Carney and Hap Edwards. Rather amusingly, the annual broadcast of Loretta Young's telling of *The Littlest Angel* at 8:00 p.m. was followed by *Music to Decorate By*. Somehow, one figures that if the decorations are not up by 8:00 p.m. on Christmas Day, it's probably time to chuck the whole season and wait for next year.

The staff of radio station WKBC celebrated Christmas in this vintage shot from the early 1930s. Shortly thereafter, the station would be bought by the *Birmingham News* and change its name to WSGN (for "South's Greatest Newspaper").

A lot had changed in radio by 1968, but during that Christmas season, powerhouse station WSGN started a rather novel concept—not on the air, but on the street. Appropriating a vacant building on Nineteenth Street between First and Second Avenues, or across from Pizitz, WSGN joined with area merchants to open a "Hospitality Center" as a refuge for those who needed a bit of relaxation after hours of pounding the pavement in search of the perfect gifts. In those days, that primarily meant women, so the center provided cribs, strollers, restrooms, one hundred chairs and continuous Christmas music on tape (though this last element might have been something the shoppers were trying to get away from). It was certainly 1968, because the hospitality hostesses were described as "garbed in their smart-looking bell-bottomed slacks and jackets."

It does not take a broadcast historian to know that by the 1960s, television had long since replaced radio as the preferred medium of entertainment. The Birmingham TV stations all did their parts to make things merry from Thanksgiving through Christmas Day. One of the most dependable ways of doing this was to carve out a bit of time each afternoon for a Santa

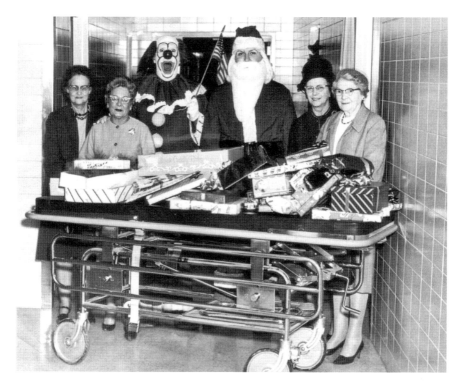

WBRC-TV's Bozo the Clown (Ward McIntyre) and Santa Claus (Keith Williams) made many personal appearances during the Christmas season, including this one at the Children's Hospital.

Claus TV show, where the right jolly old elf would read letters from children and generally give sage advice on how to be good enough to reap major dividends under the tree. This tradition actually originated in radio, where a Santa could be heard ho-ho-hoing over the airwaves daily. Loveman's was sponsoring its own Santa over station WKBC as early as 1931, and Pizitz brought St. Nick to radio listeners for many more years.

On Channel 6, the Santa on duty was station promotions whiz Keith Williams. Over on Channel 13, that veteran Santa Dave Campbell could be found holding down his throne most years during the 1960s and 1970s. Campbell had been playing Santa for so long that he could have done it blindfolded, but that would have looked rather odd on the air. Things threatened to get a bit odd anyway; Campbell had a habit of telling kids that if they were going to leave milk and cookies for him on Christmas Eve, they should go ahead and leave some olives for the reindeer. Fellow Channel 13 traveler Cousin Cliff Holman eventually convinced his pal to change the

olives to something more people would actually enjoy having around the house, such as raisins. Campbell agreed, and every year, he would instruct the youngsters to be sure to leave some raisins for Rudolph, as they were his favorite food and made his nose light up its brightest.

(Holman and Campbell were old partners in the Christmas game. Back in 1950, the two of them had been teamed for Loveman's *Mister Bingle* daily TV show. Holman served as puppeteer and voice for the snowman marionette with the inverted ice cream cone hat—a character owned by Loveman's parent company, City Stores—while Campbell acted as the comedic duo's straight man in front of the puppet stage. Each day, the intrepid duo would ad-lib their way through a fifteen-minute commercial promoting sundries sold by Loveman's as perfect Christmas gifts.)

Apparently Campbell's Santa was not the only one on Channel 13. In 1963, Yeilding's department store advertised that its own Santa could be

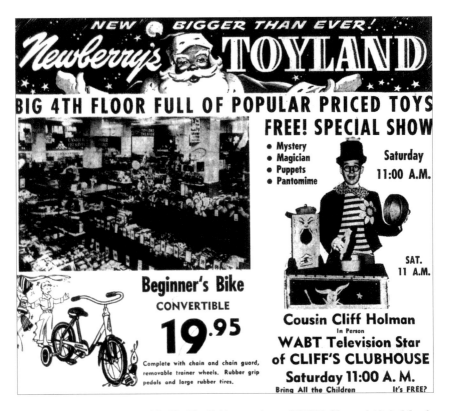

Cousin Cliff Holman began his *Tip-Top Clubhouse* series on WABT, Channel 13, in March 1954. By that year's Christmas season, he was the star attraction of J.J. Newberry's toy department.

seen on that station from eight to eight thirty on Saturday mornings. Kids could bring their letters to Yeilding's toy department and drop them into the Wishing Well for possible selection to be read on the air.

Apart from Santa's own program, there were naturally many more Christmas celebrations associated with the Birmingham stations' more regularly scheduled kids' shows. Benny Carle, Cousin Cliff, *Bozo the Clown*, *Romper Room* and the jailhouse set presided over by Sergeant Jack—they all got into the holiday mood in varying degrees.

Cousin Cliff and Christmas teamed up from way back—even before Cliff Holman was a cousin, in fact, as we just saw in the discussion of his first TV program, *Mister Bingle*. His famous nickname originated in March 1954, and by that year's Christmas season, he was a featured attraction in Newberry's fourth-floor toy department. As Holman's first child, daughter Lynn, was born shortly before Christmas Day that year, her on-air birthday celebration became an annual holiday week tradition well into the 1960s.

The various attractive ladies who served as schoolmarms on *Romper Room* (the only local kids' show to air on all three Birmingham stations at one time or another) also made Christmas celebrations a regular part of their program. In 1968, the owners of the *Romper Room* franchise, Bert and Nancy Claster of Baltimore, teamed up with Christmas Seals in an unusual way. The stamps' design that year featured the legendary partridge in a pear tree of musical renown, and an enlargement of the bird's outline was mounted on the wall as part of the *Romper Room* set. Daily, viewers were urged to get their parents to buy extra Christmas Seals to mail in to teacher "Miss Carol" Aldy and WAPI-TV, the goal being to completely cover the partridge art with the tiny, gummy stickers.

Meanwhile, back at WBRC, longtime host Benny Carle had an experience that he enjoyed retelling on multiple occasions. It seems that for one reason or another, the station's usual Santa Claus, Keith Williams, was unavailable one day and Carle was reluctantly persuaded to fill in for him. Carle realized that he was ill-equipped to be Santa, but station management decreed that he had the most experience in talking to kids, so he was going to do it or else. Benny's story then involves Bart Darby, a staff announcer who is best remembered for being WBRC's first Bozo the Clown (until he left town and Ward McIntyre inherited the job). According to Benny, he got suited up in his Santa suit and was prepared to go on the air live when Darby announced, in his most stentorian tones, "Boys and girls, it's 4:30 and time for Santa Claus—and here's Benny Carle!" Benny himself was the first to admit that he never let the truth get in the way of a good story, so we will have to take that anecdote for what it's worth.

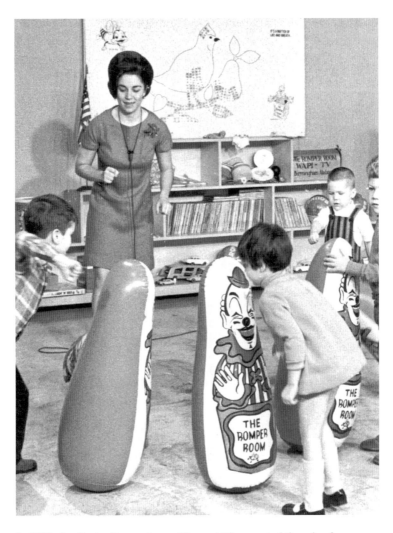

In 1968, the *Romper Room* series on Channel 13 promoted the sale of Christmas Seals by encouraging kids to send in enough stamps to completely cover a large drawing of that year's emblem, the famed partridge in a pear tree, seen here behind schoolmarm "Miss Carol" Aldy. *Carol Aldy collection.*

(There were rare occasions when Cousin Cliff would be talked into playing Santa, but he soon gave up that opportunity. It seems that his distinctive voice—which remained with him until his last days on earth—was an immediate giveaway as to his true identity.)

Until 1970, children who looked forward to the annual airing of some of the now considered classic animated Christmas specials sometimes had to

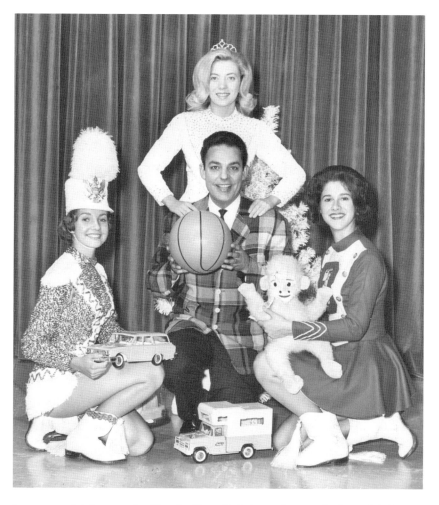

It was a tough job promoting Toys for Tots with helpers who were far beyond their tot years, but WBRC's children's show host Benny Carle gave it the old college try in this publicity shot.

watch both the clock and the calendar. For many years, Birmingham had only two commercial TV stations, and of course, there were three television networks. WBRC, Channel 6, had been a CBS affiliate during most of the 1950s, but in 1961, it elected to join up full time with ABC. That left WAPI, Channel 13, to handle both NBC and CBS programming, and the result was that at least some programs from each network were never seen in Birmingham at all, while others were seen on a delayed basis at odd times of the day or week.

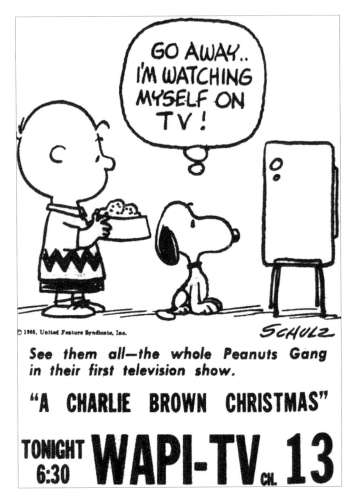

Until 1970, when Birmingham finally had full-time affiliates for all three television networks, shows could not always be counted on to air at their advertised times. The rest of the country saw the debut of *A Charlie Brown Christmas* on December 9, 1965, but Birmingham viewers had to wait until the following evening.

For example, on December 6, 1964, when the rest of the country was seeing the debut telecast of Rankin/Bass's *Rudolph the Red-Nosed Reindeer* on NBC, viewers in Birmingham could not hear Burl Ives as Sam the Snowman because WAPI was busy carrying the NFL game pitting the Los Angeles Rams against the San Francisco Forty-Niners. A year later, *A Charlie Brown Christmas* premiered on CBS all over the country on December 9—but Birmingham saw it the following evening.

Things were a little better after WBMG, Channel 42, went on the air in October 1965. Although technically an independent station, soon WBMG obtained the right to air CBS and NBC programs for which there was no room on WAPI's crowded schedule. WAPI had first choice of what to air in its network time slot, what to delay and what to drop altogether, and WBMG got the rejects. This gave Birmingham residents a bit better chance of seeing at least some shows at their advertised times. *How the Grinch Stole Christmas* debuted on CBS one week before Christmas, December 18, 1966, and Birminghamians actually got to see it on WAPI that day, sponsored locally by the First National Bank of Birmingham and the Birmingham Trust National Bank (BTNB).

The local stations would sometimes produce their own holiday specials, just as had been done in radio. For example, in 1967 Birmingham's educational television (ETV) station presented an adaptation of the Horatio Winslow story *The Lost*

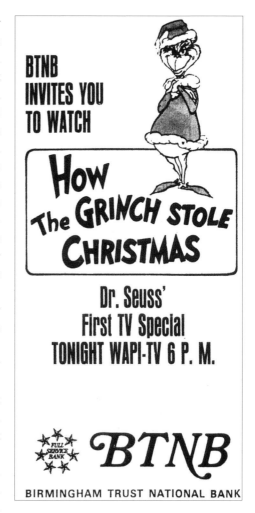

BTNB INVITES YOU TO WATCH

How the GRINCH STOLE CHRISTMAS

Dr. Seuss'
First TV Special
TONIGHT WAPI-TV 6 P. M.

BTNB

BIRMINGHAM TRUST NATIONAL BANK

There might have been some whose opinion of bankers made it especially appropriate that Birmingham Trust National Bank was one of the sponsors for the 1966 premiere of *How the Grinch Stole Christmas.*

Halo with some distinctive talent in the cast. Narration was handled by ETV coordinator Evelyn Walker, who more than twenty years earlier had been the beloved "Miss Ann" who read the daily comic strips over radio station WSGN. Her co-performer was Hubert Harper, a University of Alabama instructor and part-time actor who would still be with UAB in the 1980s; his father was the editorial cartoonist for the *Birmingham News* for decades.

For this simple 1973 greeting, WBRC-TV used the familiar image of its own beautiful white-columned studio building atop Red Mountain. For a few years, WBRC even had its own lighted living Christmas tree on the front lawn.

Illustrating the tale was Birmingham-Southern student Howard Cruse, who would eventually become art director and puppeteer for WBMG's *Sergeant Jack* show.

Speaking of WBMG, in 1979 that UHF station presented a three-hour Christmas show benefiting the Muscular Dystrophy Association. Featured performers included future gospel music superstar Bob Cain (with his group the Cainbreakers); dance school impresario Dale Serrano; singer Demetriss Tapp; *Birmingham News* columnist Dennis Washburn's often written-about wife, Bunny; and unidentified personalities from WERC Radio.

No one in television had such a long-running series of Christmas specials as Edward Burns, aka Country Boy Eddy. It was probably a coincidence that Burns chose to retire from his thirty-seven-year early morning TV series on New Year's Eve 1993, but for many years thereafter, he would get together with members of his old gang, and plenty of new ones, for Christmas specials taped on location around northern Alabama. Sometimes he could be found on the vast Hallmark estate on I-65 north of Gardendale; another year he would be hanging out at the western theme park Old York USA; but even as late as 2014, WBRC was still rerunning various Country Boy Eddy Christmas shows at odd times of the day or night.

In 1980, the *Birmingham News* interviewed a number of local personalities from various walks of life, including politics, sports and entertainment, to find out their most special Christmas memories. Donna Hamilton, who was at the time working on both WBRC's *Morning Show* and *PM Magazine*, related the melancholy story of her first Christmas morning away from home: "Santa always came to see us, even until I was 20 years old. The first year I lived away from home, Santa didn't come. I woke up and went out into the living room and he hadn't come; the living room was just as I had left it the night before."

A more cynical WBRC news personality, Bruce Burkhardt (who sometimes confounded viewers with his satiric "Burkhardt's Beat" segments), stated: "You can't avoid the Christmas spirit—you get hit with it!" In his native New England, Burkhardt said, he grew up with "little shops with old-fashioned Christmas decorations" instead of malls. "It was a delight as a kid. Nothing could top it. For that reason, it doesn't have the same magic as it did then, but someday I hope to recapture that."

With all the moaning and hand-wringing that could be counted on each year regarding the commercialism of Christmas (although a person would have to be about two hundred years old to have ever seen a time when the holiday season was *not* commercialized), it might have seemed almost

Tom York, the longtime host of WBRC-TV's *Morning Show*, hid behind a Santa suit to plug Toys for Tots with the assistance of some adorable companions.

blasphemous to suggest that some people's eventual fond memories would be about—wait for it—the Christmas commercials that aired incessantly on both radio and TV during November and December.

It was not unusual for a business that aired commercials all year to break things up with a special alternate holiday version. Let's take the case of Burger in a Hurry, that Birmingham-based chain that sprang up in the wake of the success of other fifteen-cent burger joints inspired by McDonald's. The most famous of these in Birmingham, of course, was Jack's Hamburgers, but Burger in a Hurry established its own loyal fan base that still remembers it fondly. For most of the year, the Burger in a Hurry radio jingle played with a squeaky voice, not unlike Alvin of the Chipmunks, representing a single line spoken by the company mascot, Mister Realee Good. (He could have been judged as either a Martian or a leprechaun, or maybe he was a leprechaun from Mars instead o' the Old Sod.) Either way, the short jingle went:

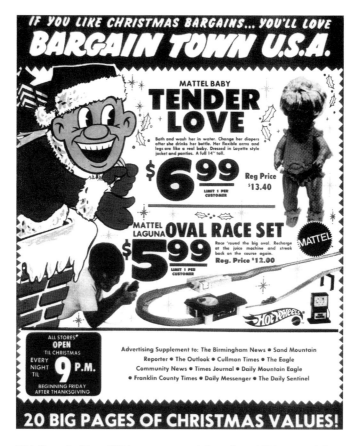

This Bargain Town USA newspaper ad dates from 1970, around the same time the variety store chain began using its holiday radio jingle: "That's why people from the North Pole down / Say 'If you like bargains, you'll love Bargain Town!'"

Come back to Burger in a Hurry,
The home of Mister Realee Good;
Once you've tried a Burger in a Hurry,
You'll come back …
GOOD: "Y'all come back!"
We knew you would!

Variations of this jingle were produced in differing musical styles (including a country version). For the Christmas season, the musical background included jingling bells, and Mister Realee Good's "Y'all come back" line was replaced with a hearty "Ho ho ho!"

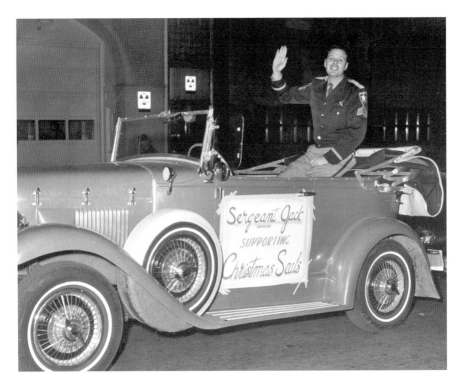

Neal Miller was seen as Sergeant Jack on WBMG-TV, Channel 42. Unknown to nearly everyone, he was also the Santa voice on the Christmas version of the Bargain Town USA song. *Miller family collection.*

Similarly, there was ubiquitous discount store chain Bargain Town USA. From January through October, on both radio and TV, listeners generally heard singer Teri Honeycutt grooving to a cha-cha-cha beat:

> *That's why people from all over town*
> *Say, "If you like bargains, you'll love Bargain Town…U-S-A!"*

However, things would change once the Christmas shopping season set in. Over artwork of the Bargain Town logo character, bucktoothed Buckworth, dressed in a red suit and whiskers, Honeycutt's jingle was replaced by a deep voice and new lyrics, giving the chain an endorsement that was hard to beat:

> *That's why people from the North Pole down*
> *Say, "If you like bargains, you'll love Bargain Town…ho ho ho ho ho ho."*

Unknown to practically everyone, Bargain Town's Santa voice was none other than radio disc jockey and kids' TV show host Neal "Sergeant Jack" Miller. Jean, his daughter, reports that Miller frequently laughed wryly about that particular job. Since he had no inkling his Santa performance was going to run for years, he never thought to ask for residuals upon agreeing to do it; he never received a further farthing after his original pay for performing the jingle. (Both the Honeycutt and Miller jingles were finally retired sometime prior to 1983, when Bargain Town hired a new ad agency that junked most of the commercial elements that had become identified with the chain.)

One well-remembered Christmas TV commercial that, unfortunately, seems not to have survived on film or tape was produced for the Bruno's grocery store chain in the mid-1970s. The company had long used the black-and-white Bruno Bear as its mascot (more on that in our concluding chapter), but this commercial produced by the Steiner-Bressler ad agency brought Bruno's bruin to animated life, accompanied by his entire family.

Naturally, since Birmingham did not have an animation studio that could produce that sort of thing, according to agency executive Harry Bressler, the actual animation was done in New York City. Artwork from the spot was used by Bruno's on its paper bags for many Christmas seasons thereafter, and these occasional artifacts are the only way anyone can see how it looked. Many people remember the jingle, which ended with the cheery greeting, "Happy holidays start at Bruno's, for YOU and YOU and YOU!"

The Bruno's commercial is only one of many local ads that do not seem to be available for researchers and nostalgic adults to see. Since there was virtually no thought given to preserving such productions for history, the ones that did survive have been retained almost unilaterally by accident.

The largest batch of these originates with this author. My family got the first VHS video recorder sold for home use (the RCA Selectavision) the day it went on sale in October 1977. Those of you who were not around at the time might not realize that in those early days, blank VHS cassettes could sell for as much as thirty dollars each, so one had to be very selective in what to save. Had I known how valuable it would have been as a historic record, I would have made it a point to record at least one example of all the local programming, but the perspective from 2015 was of little use in 1977.

At some point during December 1977, I had to attend some now forgotten high school function and set the timer on the VHS recorder for the annual broadcast of *A Charlie Brown Christmas* on CBS. By having the timer click on a couple of minutes before the network feed began, and continue recording after the show, I captured the two blocks of local commercials from WBMG,

Around 1975, the ad agency for the Bruno's supermarket chain came up with a commercial, animated in New York, that featured mascot Bruno Bear and his entire ursine family.

and these are practically the only complete examples of Birmingham's Christmas ads.

We have already discussed the Western Hills Mall commercial—with Sokol's, Santa and a mini-skirted helper—in our previous chapter. Other ads in the two blocks have just as much nostalgic footage. One, sponsored by "the Vestavia merchants" as a group, spends most of its footage on men's clothing store the Cambridge Shop, with a very brief tag at the end inviting everyone to come visit Santa (whose throne and setting are shown but exact location not specified). A commercial for Feeny's, a jewelry store with locations in Homewood, Roebuck and Eastwood Mall, does not appear to have been produced in Birmingham. As with animated Bruno's bears, it has a slick, filmed look that betrays its nonlocal origination.

One of the most interesting commercials in this group is for Pizitz. It opens and closes with footage of ballerinas pirouetting around a giant gift box, with the Pizitz logo suspended above in silver glittery lettering. The body

of the spot promotes a line of pendants, brooches and hatpins, for which the attractive model poses in front of wintry scenery that might very well have been used in that year's Enchanted Forest. As the ballerinas execute one final graceful dance at the end, a tag line encourages one and all to "Support the Birmingham Ballet."

While on that subject, we should mention here that the Christmas season has long been a time for Birmingham to witness dueling Nutcrackers. The Alabama Ballet has its exclusive rights to the famous George Balanchine choreography, with the Birmingham Ballet performing a different rendition. By the twenty-first century, the holiday spectacle was so familiar as to be ripe for parody, and both ballet companies took advantage of that. Beginning in December 2000, the Alabama Ballet would present, for one night only, a "Nutty Nutcracker" performance that each year transformed the usual family of the piece into various well-known TV personalities, including the Addams Family, the Beverly Hillbillies, the Brady Bunch and the Simpsons. The Birmingham Ballet countered with the "Mutt-Cracker," adding more than a dozen dogs to the regular cast, with a portion of the ticket sales going to the Greater Birmingham Humane Society.

Some commercials for Birmingham's much-loved Parisian stores also survived through various means. Ad agency owner Evelyn Allen was responsible for producing them in the early to mid-1970s and saved not only the completed spots but much of the raw footage that went into making them. Quite a few feature Allen's daughter Lori, who would later be the wife of Governor Don Siegelman, while others prominently star Jim Lucas Jr., son of the radio mainstay and WAPI-TV "weather girl" Rosemary.

Some examples of circa 1972 Parisian Christmas commercials show the store's special holiday logo, with the first *A* in Parisian shaped like a Christmas tree. The easy listening–style jingle promises holiday shoppers that "dreams are made of things from Parisian / All the way from hers to his / No matter the style or what the season / Whatever you want, Parisian is!" A tradition that continued even into later eras was to feature either film footage or still photos of Parisian sales clerks, giving each his or her own personal appearance in the company's holiday ad campaign.

A Parisian spot from the aforementioned 1977 batch caught on early VHS tape takes a somewhat different approach, depicting a variety of kids in their winter coats lined up for an audience with Santa. (One young boy entertains an even younger girl with a Kermit the Frog doll.) After the announcer opines that Parisian's are "the type of savings that make Santa go 'ho ho ho,'" we get a very brief rendition of a new jingle—"We…wrap a

smile…with every gift from Parisian"—over the obligatory views of longtime company employees.

By 1982, Parisian was really getting modern in its Christmas campaign. There is a problem with trying to be too current, though. While the earlier spots are charming for their glimpse into a bygone department store era, the 1982 ad campaign simply looks a bit embarrassing in its attempts to be "hip." It was built around the talents of ten-year-old Cary Guffey, who as a toddler had played a memorable role in the blockbuster *Close Encounters of the Third Kind*. For Parisian's commercials, Guffey was teamed with a robot known as "E.C.," which showed elements of having been cannibalized from both *Star Wars'* R2D2 and the eponymous star of *E. T., the Extraterrestrial*. The newest jingle, "Christmas at Parisian Is Out of This World," was very loosely based on the tune of "God Rest Ye Merry Gentlemen" but in a barely recognizable conversion. The models, with their designer Calvin Klein jeans and roller disco poses, today seem more outdated than the 1970s fashions on the kids in the commercials from a decade earlier.

Besides radio and television, there was another source of news and entertainment back in those days; it was called a "newspaper." What's that, kids? You've never seen a newspaper? Well, they were these big sheets of folded paper with news articles and ads and comic strips, and you actually had to hold them in your hands and turn the pages in order to read them. (We old-timers used them to keep up with the daily races between the woolly mammoths and the saber-toothed tigers.) During the Christmas season, this antiquated method of disseminating information followed much the same pattern as the broadcast media, with the contents changing to fit the demand.

For many years, the *Birmingham News* had what could be considered the print equivalent of the various animated specials airing on television. Beginning in the early 1950s and continuing intermittently into the 1990s, there would be a syndicated Christmas-themed comic strip that ran one installment per weekday, beginning just before Thanksgiving and ending with the denouement on Christmas Eve.

For most of the 1950s, this annual tradition depicted the continuing adventures of Rudolph the Red-Nosed Reindeer, drawn by artist Rube Grossman. The cast of characters was the same as Grossman was using in a contemporary series of Rudolph comic books, with the same personalities. Rudolph was frequently portrayed as an egotistical know-it-all, thanks to his celebrity status, and Santa often came across as a stereotypical grouchy "boss" rather than his usual jolly self. Supporting roles were handled by

pugnacious Grover Groundhog and the North Pole's resident villain, J. Baddy Bear.

In 1957, Rudolph was replaced by a self-contained one-shot story, "The Snowman's First Christmas," credited to Jim Miele and Marv Lev. In 1960, with the centennial of the Civil War approaching (not to mention the emerging civil rights movement), the *News* carried, instead of a Christmas story, a continuity known as "Under the Stars and Bars," not surprisingly subtitled "The Glory of the Confederacy." One does not have to guess at where the artist and writer's sympathies lay.

The most fondly remembered annual tradition began in 1961, with the first installment of what would become a long series of annual Disney Christmas comic strips distributed by King Features Syndicate. More often than not, the storyline would be based on whatever classic Disney animated feature had recently been released, charmingly mixing characters from various stories with joyous abandon. One of the most extreme examples is the 1962 story, in which the evil Maleficent again succeeds in turning her nemesis Aurora into a Sleeping Beauty. When the prince's kiss fails to awaken the snoozing lass, to the rescue comes—Ludwig Von Drake? Yes, the genius duck from the *Wonderful*

A highly anticipated feature in the *Birmingham News* each year was a serialized comic strip running on weekdays from Thanksgiving until Christmas Eve. In the 1950s, most years' stories depicted the continuing adventures of Rudolph the Red-Nosed Reindeer and his many friends and enemies.

119

BEWARE OF A CROW BEARING CHRISTMAS GIFTS!

IN A FEW MINUTES YOU CAN TAKE BACK A GIFT TO THE JOLLY ONE AT THE NORTH POLE...

W.D.P.

Not even Santa Claus is aware of what the evil fairy, Maleficent, is cooking up to DE-STROY Christmas!

What will Maleficent's potent brew do to the spirit of Christmas? Will her crow succeed in carrying out the wicked plot?

You'll find out in the exciting new holiday story strip—

Walt Disney's

Santa's Christmas Crisis

Starting Monday, Nov. 30th in the

𝕿𝖍𝖊 𝕭𝖎𝖗𝖒𝖎𝖓𝖌𝖍𝖆𝖒 𝕹𝖊𝖜𝖘

Beginning in 1961, the annual newspaper Christmas comic strip usually originated with the Walt Disney Studios. Each year, Santa Claus had to contend with one or more of the notorious Disney villains who were out to destroy the holiday for everyone.

World of Color TV series travels "through time and space" to rescue Aurora by giving her a sleeping pill but placing it in her mouth upside down, causing it to work in reverse.

Future stories included "Cinderella's Christmas Party" (1964), "Snow White's Christmas Surprise" (1966), "Dumbo and the Christmas Mystery" (1967), "Santa Claus in Never Land" (1968), "The Quest for Christmas" (1969), "Santa's Christmas Crisis" (1970, with Maleficent again up to her old tricks), "The Christmas Conspiracy" (1971, combining comic book baddies the Beagle Boys with the mice from *Cinderella*), "The Magic Christmas Tree" (1972), "A Castle for Christmas" (1973, when Bambi meets the wicked witch from *Snow White*), "Santa and the Pirates" (1975), "Captain Hook's Christmas Caper" (1976, in which the pirate teams with the Big Bad Wolf and J. Worthington Foulfellow to form an unholy trinity), "No Puppets for Christmas" (1977), "The Day Christmas Was Banned" (1978, Dumbo meets the cast of *Robin Hood*) and "Madam Mim's Christmas Grudge" (1979). The annual strips became available more sporadically in the Birmingham paper after that, but there were still occasional stories, such as "A Zip-A-Dee-Doo-Dah Christmas" (1986, in which Uncle Remus speaks perfect English but Brer Rabbit, Brer Fox

and Brer Bear retain their southern dialects) and a 1992 story based on *Beauty and the Beast* that was later loosely adapted for a made-for-video animated feature, *The Enchanted Christmas*.

Whether on radio, television or in the newspapers, there was plenty of entertainment available to keep one occupied during those weeks leading up to Christmas Day. At its basis, though, Christmas was about home and family, and it is to those local traditions that we shall turn our attention in our final chapter.

HOME FOR THE HOLIDAYS

Now, as we prepare to bring this lengthy discussion to a close and as we count down the hours until midnight on Christmas Eve, we will spend these remaining pages examining some traditions that, for the most part, took place quite far from downtown in both spirit and character. People worked and shopped and were entertained downtown, but most of them did not live there. The Birmingham metro area was composed of scores of individual neighborhoods, and it was in those that many people's most intimate Christmas memories were made.

Most appropriately, churches—whether large or small—were the guardian angels of the true meaning of Christmas. One of the ways many of them chose to observe the season was with a "Living Nativity Scene." These outdoor events seem to have been an outgrowth of the traditional indoor church Christmas pageants, which naturally often included a tableau with costumed members portraying Mary, Joseph and the rest. To judge from yellowing newspaper clippings, one of the first local churches to bring the indoors outdoors was All Saints' Episcopal in Homewood; the 1956 coverage of its living Nativity scene refers to it as "unusual," indicating that the idea was not overly common at the time.

It certainly caught on fast because by the early 1960s, All Saints' had been joined by Woodlawn Methodist and Thirty-Fifth Avenue Baptist. Even later, Mountain Brook Baptist, Shades Crest Baptist and Pleasant Ridge Baptist joined in the chorus, most augmenting the live actors (and frequently live animals) with recorded choir music and narration. Even when a single

Above: The date and location of this photograph are unknown, but most likely your school had a Christmas pageant that looked a whole lot like this one. *Birmingham, Alabama Public Library Archives, Catalogue #BBE23.*

Left: "Living Nativity scenes" became a quite popular way for churches, both large and small, to take the Christmas story out of their sanctuaries and onto their lawns.

124

church was not involved, the tradition could still carry on; in 1977, a group of ten Homewood youngsters joined forces to present their own living Nativity scene at a home located at 227 Poinciana Drive for the entire week leading up to Christmas.

One church in Forestdale did not even have to wait until December to celebrate. In the early 1980s, the pastor of Hillview Baptist Church was Charles Christmas—or, to use his full name, Charles Merry Christmas. The fifty-three-year-old minister gained newspaper coverage not only for his unusual name but also for being the first person in his neighborhood to decorate his home each year. He told a reporter, "I keep the Merry there and bring it out when I need it…it has never hurt."

Some churches found unique ways to celebrate the season. For a number of years, Highlands Methodist was renowned for its annual Boar's Head Festival, re-creating a Yuletide celebration of the 1500s. A typical description of the pageant elaborated: "Beefeaters (traditional guardians of English kings), a sprite bearing a candle that symbolizes the coming of Christ into a darkened word, a minstrel, knights and attendants, all will be joined by the chancel choir and members of the Birmingham Symphony Orchestra in the event."

Ensley First United Methodist Church filled its sanctuary with twenty-five evergreen Christmas trees decorated to represent various foreign lands. Pastor Bob Storey explained, "It's a way of showing the universality of Christmas around the world."

We have all heard that mossy old cliché "Charity begins at home," and so it was that people who caught the Christmas spirit could find various ways to help, even in addition to what their churches might have been doing. One of the earliest appearances of such a charitable opportunity each year was when Christmas Seals would go on sale. Christmas Seals were introduced in the United States in 1907, originally a fundraiser for the Red Cross. Eventually, they were absorbed by the National Tuberculosis Association, and that dreaded disease remained their primary target until the 1970s. Once tuberculosis became nowhere near as common as it once was, the renamed American Lung Association assumed control of the colorful little stamps in 1973. The taste of licking the gummy side of the stickers and affixing them to family Christmas cards is one of those many intangible things that combine together to represent Christmas in many kids' memories.

And make no mistake, once the baby boom generation was booming babies right and left, those impressionable youngsters were enlisted to create one of the biggest armies to promote the sale and use of Christmas Seals. In our last chapter, we saw how *Romper Room* became a big Seals promoter,

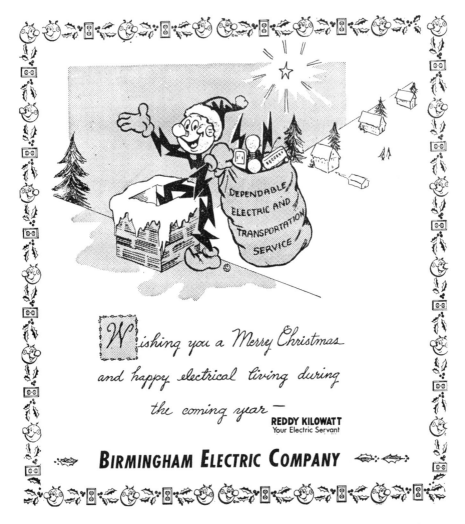

Since so much Christmas decorating required the use of more electricity, it is no wonder Birmingham Electric Company (BECO) and mascot Reddy Kilowatt were so anxious to send holiday greetings.

but kids were not the only ones encouraged to promote Christmas Seals, of course. In 1964, a most unusual promotion involved Birmingham's most visible symbol, Vulcan, on his pedestal high atop Red Mountain. A lighted rendition of the Tuberculosis Association double-barred Cross of Lorraine was mounted to the side of the pedestal facing downtown and surrounded by lights forming the outline of a Christmas tree. The purpose of this arrangement was described in mid-November of that year:

Every night, a burst of fireworks will glitter above the Alabama State Fairgrounds. The noise and the beautiful display in the sky will remind Birmingham and Jefferson County to take a look at the Christmas tree of lights on Vulcan.

If suspicious chest X-rays are found that day in the Christmas Seal X-raymobile in downtown Birmingham, or at the Chest X-ray Center at 900 South Eighteenth Street, red lights will flash on the tree—one light for each case found.

Birmingham
JUNIOR LEAGUE
Newsheet

Volume XXI	Birmingham, Alabama, December, 1949	Number 6

Beginning in the late 1940s, the Junior League sponsored annual caroling pilgrimages to collect money for children with speech and hearing impairments. The slogan: "They Sing So That Others May Speak."

Also, at the intersection of Ninth Avenue and Eighteenth Street South, near the Chest X-ray Center, there was a Christmas tree quite similar to the one glowing in Woodrow Wilson Park. This one was provided each year by Mrs. Horace Hammond and Catherine Hammond Collins (her daughter), who told a reporter, "Our family a number of years ago sought to find a way to symbolize this wonder spirit that finds expression in Christmas Seal giving. The tree and the lights are our gift to the great fight against tuberculosis."

Have you ever heard the slogan "They Sing That Others May Speak"? That was the mantra for an annual program of Christmas caroling that began immediately after World War II as a way to benefit Birmingham children with speech or hearing impairments. For its first ten years, it was a project of the Junior League but in 1958 became an official outreach of the Alabama Foundation for Speech and Hearing.

On a designated night—sometimes Christmas Eve, sometimes earlier in the season—groups of carolers ranging from children to teenagers would sing in "every neighborhood in the county," according to the official promotion. The carolers would have containers to collect donations, and once their designated routes were done, they would all gather at Woodrow Wilson Park for a community Christmas singing. Just when this charming tradition was last held is uncertain, but what is more certain is that sending young people out alone to collect money in unfamiliar neighborhoods is something that would not be done today. It is true enough that the root meaning of Christmas never changes, but unfortunately, the same cannot be said for some of the holiday's most attractive accoutrements.

Helping unfortunate children seemed to be a common theme among Christmas season charities, and it was an especially important job when it came to those youngsters who were having to spend their holiday in the hospital. In 1948, Santa Claus paid an early visit to the Crippled Children's Clinic, and the reporter who accompanied him could hardly express the effect that simple act had:

> *Old Santa had trouble keeping tears from his eyes as he saw the immediate results of his visit. Tiny eyes sparkled. Tiny hands clasped together and unclasped in nervous excitement. One tot strapped to a hard board moved a big toe back and forth briskly as she talked to Santa. A short time ago, she was unable to move even that much of her polio-stricken legs.*

Like tuberculosis, polio eventually ceased to be the major threat it was in 1948, but kids and hospitals continued to be a combination no one wanted.

Local businesses got into the spirit of helping the caroling program after it became an official outreach of the Alabama Foundation for Speech and Hearing. Here, in 1960, a Sears deliveryman temporarily covers the store's logo on his truck with a seasonal poster. *Polly Chambers collection.*

In 1982, Children's Hospital began sponsoring the annual Festival of Trees, a concept that was not unique to Birmingham but used as a fundraiser by children's clinics nationwide. More than one hundred Christmas trees would be set up at the Birmingham-Jefferson Civic Center and decorated by local designers and organizations. Sales of the decorated trees, in addition to the admission charge, went to help fund the hospital.

But one did not have to be a child to be seriously bummed out by spending Christmas at a hospital. Birmingham's infirmaries did their best to be sure that those who were unable to go home would still have as memorable a holiday as possible. The VA Hospital decorated its main entranceway with a diorama depicting the three wise men following the Star of Bethlehem.

South Highlands Infirmary featured Christmas trees with ornaments fashioned by nurses during their off-duty hours. Similar activities went on at the Jefferson-Hillman Hospital and St. Vincent's Hospital, with the staffs working overtime to supply decorations, gifts and Christmas dinners. At West End and Highland Baptist Hospitals, the nursing students sang Christmas carols. And of course, the aforementioned Crippled Children's Clinic and

The lighted star atop Carraway Methodist Hospital is another of those rare items that started as a Christmas decoration but became a year-round sight. The hospital also had its own "living Christmas tree" in front of the main entrance.

Children's Hospital did everything imaginable to help their young patients remain on the cheerful side.

There was one hospital, however, where the main Christmas decoration became more than just a holiday symbol; it became the facility's year-round trademark. Just how it originated has been told in a couple of different ways. In 1980, Ann Sorge, a former director of nursing for Carraway Methodist Hospital, told an interviewer that in the mid-1950s, the staff wanted a Christmas decoration for the school of nursing. Sorge recalled that maintenance man Edwin Paschal built a giant star out of plywood and light bulbs. "It looked like the wrath of God in the daytime, but at night it was pretty," Sorge said.

The transition from annual decoration to 365-days-a-year emblem is said to have begun in 1965, when Carraway Hospital decided to leave the star in place permanently. Whether that was Paschal's original plywood star or a different one seems to be a matter of conjecture. It is said that a couple named John and Ruth Badeau donated the star to the hospital, which may refer to the second, permanent star. Also, while Ann Sorge stated that the Paschal star was outlined with white lights, most people remember the permanent star as having peaceful blue lights.

Either way, in 1976 the star outlined in lights was replaced by a new one crafted by Birmingham's legendary Dixie Neon Company. That final rendition of the star was made of blue plastic, lighted from within, and revolved on a post on the roof of the hospital's Goodson Building. It became a symbol of comfort to a whole new generation of healthcare workers, especially those whose responsibilities involved the hospital's Life Saver helicopter. Pilot Brooks Wall told a reporter, "If you've really got a fight for life on your hands, it's a relief…You always feel good when you see that old blue star turning." The blue plastic star was still shining over the hospital when it finally closed for good in October 2008, most people no longer associating it with its origins as a Christmas decoration.

(There was another star that strongly resembled Carraway's original—actually, three of them. The tallest structure in Ensley, the Ramsay-McCormick Building, was at some point adorned with giant Christmas stars on three of the four sides of its topmost tower. Unlike Carraway's, the Ramsay-McCormick stars were only illuminated during the holiday season, although they remained in place and were visible during the daytime all year. As the building fell into disrepair, the stars rusted into oblivion, but in the summer of 2015, pieces of them could still be seen clinging to the building's carcass like barnacles on a ghost ship.)

Jack's Hamburgers had a long association with the Christmas season, dating back to the first location's grand opening on the day after Thanksgiving 1960.

Even though people most often thought of downtown as a Christmas destination, out in the suburbs where most of those folks lived there were other businesses that made merry. One of those, the ubiquitous chain of Jack's Hamburgers drive-ins, actually made its debut during the Christmas season. It was on the day after Thanksgiving 1960 that longtime area restaurateur Jack Caddell opened the first location of his eventual regional chain in downtown Homewood. Due to the fortuitous timing, Santa Claus was a special guest for the grand opening, as was TV favorite Cousin Cliff. (In fact, Caddell built his business into a million-dollar venture within just a couple of years simply by directing all of his advertising toward the children's market.) In reporting the upcoming grand opening, the *Shades Valley Sun* newspaper must have employed the one and only writer in Birmingham who could manage to get Cliff's name wrong; in both the headline and the body of the story, everyone's favorite cousin was referred to as "Uncle Cliff."

Christmas promotions were a staple at Jack's, even after Caddell sold the company in the late 1960s and the new owners began following the lead of McDonald's and converting from walk-up window service to indoor seating. In the early 1970s, Jack's annually offered a special Christmas glass with

the company logo alongside a row of stylized cartoon Santas (a design that was also available from other restaurant chains in other parts of the country). From the numbers of these glasses that turn up on the collectibles market today, it was surely one of Jack's most successful holiday promotions ever.

Even Jack's had to bow its head in deference to Bruno's supermarkets when it came to celebrating Christmas. Perhaps it was because the Bruno family was a devoutly religious one, but the holidays were observed in each location of that chain even more than one might expect from a grocery store. In our previous chapter we mentioned the memorable animated TV commercial with the Bruno Bear and his family, but that was only a tiny portion of it.

To use one example, in 1961 the stores offered a two-

For at least a couple of Christmas seasons in the early 1970s, Jack's offered these glasses with a highly stylized Santa.

Drink Your Coke!
KEEP THE GLASS!

it's the real thing Enjoy Coca-Cola

...BOTH FOR 30¢

Famous Libbey Quality

When you buy a big, frosty Coke® at Jack's, you get to KEEP THE GLASS!... Not just any glass either! While they last... you can order your Coke® in great looking Christmas tumblers by Libbey. Handsome, heavy-bottom tumblers decorated with a colorful, modern Santa design. So drink your Coke®... and when you're through, KEEP YOUR GLASS! Santa glasses... great for holiday entertaining! Start your collection today!

a Christmas Bonus
FROM
JACK'S
HAMBURGERS

COME SEE SANTA AT Shoney's

FREE TOYS
FOR ALL LITTLE GIRLS & BOYS

SANTA'S HOURS: DEC. 15th thru DEC. 23rd

School Days, 4:30 to 8:30 P.M.
Non-School Days, 11 to 2:30, 4:30 to 8:30

— AT ALL LOCATIONS —

**7757 Crestwood Blvd.
1037 3rd Ave., West
96 Weibel Drive
221 North 20th St.
9125 Gadsden Hwy.**

PRIVATE DINING ROOMS AVAILABLE FOR PARTIES

When Santa Claus visited the area's Shoney's Big Boy restaurants in 1969, one wonders whether he felt compelled to don a red-and-white-checkered suit to match the chain's tubby mascot.

WE HAVE A COMPLETE STOCK
FRUIT CAKE INGREDIENTS—CHRISTMAS
TREES—GIFT WRAPPINGS—
DECORATIONS

sing along with Bruno Bear
Children's Christmas Favorites

OCEAN SPRAY 303 CAN
CRANBERRY SAUCE 19¢

HEAR BRUNO BEAR
SING YOUR FAVORITE CHRISTMAS SONGS 39¢

GET YOUR OWN
BRUNO BEAR
15 INCHES HIGH $1.89
SOFT AND CUDDLY

In 1961, Bruno's shoppers could obtain their own stuffed version of the friendly Bruno Bear and a 45-rpm record in which the bruin sang Christmas songs and recited "The Night Before Christmas."

part Christmas promotion. For $1.89, shoppers could get their own plush Bruno Bear, which, quite frankly, did not much resemble the character on the logo. (His bow tie was about the only connection between the two.) For an additional $0.39, the same shoppers could obtain a 45 rpm record titled "Sing Along with Bruno Bear," starring the ursine entertainer. The performer who had the distinction of being the bear's voice is uncertain, as the pitch was raised electronically to give him a more cartoonish sound. One would hardly suspect such an elf-like voice to come from the rotund, black-and-white, bow tie–wearing cartoon bear, but apparently the Brunos felt otherwise. The bear filled up two sides of vinyl with Christmas songs and concluded by reading "The Night Before Christmas." A Bruno's Christmas jingle ensured that no one would forget from whence said record came.

Another Bruno's promotion from much later (1976) illustrates how different the whole grocery shopping experience was at the time. Shoppers

Those who are too young to remember trading stamps may wonder what all the fuss was about, but they were still highly prized in 1976, when Bruno's offered bonus stamps to those who filled one of these "Trim the Tree" cards.

were handed a "Trim the Tree Coverall Card," with twenty-four blank rectangles forming the shape of a Christmas tree. With each three-dollar purchase at Bruno's, the customer would receive one stamp to place over one of the blank spaces. Once the tree was "trimmed" (and for those who failed math, that meant spending at least seventy-two dollars), the completed card could be redeemed for three hundred bonus Top Value stamps. Those who were not around in those days cannot possibly begin to fathom what a big deal trading stamps (Top Value, S&H Green Stamps, Plaid Stamps and all the rest) were, especially in the supermarket world. Virtually anything needed for home or office could be purchased with books of trading stamps, so people went to extraordinary lengths to collect them. Bruno's "Trim the Tree" promotion illustrates just one way the year-round trading stamp frenzy could be combined with holiday jollity.

There was another type of business that few people would have connected with Christmas; in fact, it was usually associated with quite the opposite time of year. That was the tourist attraction. Now, Birmingham was hardly a Panama City Beach or Gatlinburg when it came to the number of tourist attractions in the area, but the ones that were there had at least one advantage over their cousins on the coast or in the mountains: they were open all year, not just during prime tourist season.

In 1954, the City of Birmingham had purchased Arlington, the only surviving antebellum plantation home in its immediate vicinity. With its emphasis on preserving the furnishings and lifestyles of its era, it was only natural that Arlington would make an annual tradition out of depicting a typical Christmas of the 1800s. Crowds flocked to the historic home during its "Christmas at Arlington" open house weekend each year. A reporter described the wonders to be beheld inside:

> *First floor rooms of the old home will be fragrant with fresh greenery—yew, pine, hemlock—used with fresh fruit in Della Robbia swags. Old-fashioned wreaths, tied with red velvet ribbons, will hang at each of the windows and balsam garlands will decorate the stairway to the second floor.*
>
> *The children's tree upstairs will be bright with miniature candy canes, stars, wreaths and Christmas trees, all in colorful calico. And on the mantel in the children's room, calico stockings will await Santa's visit.*

Perhaps the only thing seeming a bit out of place in this antebellum setting was a modern-looking Santa, ensconced with Mrs. Claus in the plantation

Even motels, such as the Parliament House, got into the Christmas spirit. Who was the "Baron"? The fictional namesake of the motor hotel's restaurant, the Baron of Beef. *Dixie Neon collection.*

kitchen situated behind the main house. Various high school choral groups helped maintain the proper mood by dressing in period costume and performing Christmas songs appropriate to the era.

Just as the first Jack's Hamburgers eatery debuted during the Christmas season, so did Birmingham's Botanical Gardens, which opened its blossoms to visitors for the first time the week before Christmas 1962. Therefore, horticultural holiday displays were a part of its being from the very first day. Since flowers and plants (and flowering plants!) have changed very little from that day to now, most of the same emphasis can still be found in the gardens' conservatory building today. Poinsettias were usually the focal point of any display, including the present-day tradition of crafting a towering Christmas tree entirely from the holiday staple.

By contrast, the gardens' older next-door neighbor, the Birmingham Zoo, seems to have had more mixed feelings about Christmas. In the 1950s and 1960s, it was not uncommon for the zoo to issue publicity photos of Santa posing with the resident deer, but eventually the attraction's directors

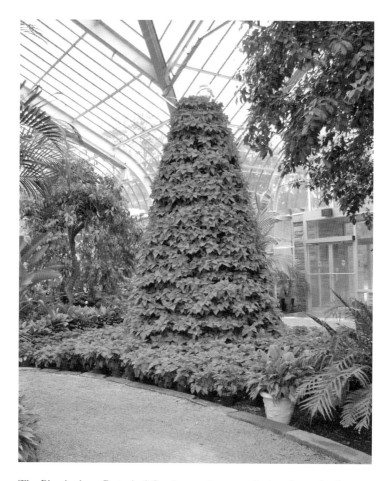

The Birmingham Botanical Gardens, quite naturally, is at its peak of splendor during the spring and summer months, but its annual Christmas displays have attracted fans since its opening in 1962.

made the decision to deliberately go in the opposite direction. In 1990, zoo employee William Reeder told a newspaper reporter:

> *If you want to go someplace that is not overwhelmed with Christmas-related stuff, this is the place. We don't do any decorating here. I'm sure that's why we attract a lot of single people, older adults and people who don't typically celebrate Christmas.*
>
> *Very few people who come to the window wish you a merry Christmas, and very few have on holiday-type clothing. It's probably not what most people expect to see on Christmas.*

The article went on to say that about forty visitors had shown up at the zoo on Christmas Day—quite a small number compared to its usual attendance.

Well, at some point between 1990 and 1993, someone at the zoo must have experienced a Christmas miracle similar to those that affected Ebenezer Scrooge and the Grinch. Beginning in early December 1993, the zoo tried something different: a display known as Zoolight Safari, turning the entire park into a giant illuminated Christmas greeting. A preview held in late September was confined to an area near the former Monkey Island (the original attraction on the zoo grounds): "Strings of lights will outline buildings, decorate trees and form animals to attract after-hours zoo visitors."

In contrast to the forty people who showed up to not celebrate Christmas at the zoo, that first year's Zoolight Safari attracted some thirty-two thousand visitors, including two thousand on its final night. Suddenly the Birmingham Zoo was in the Christmas business up to its alligators, and it has continued to this day as the home of one of the city's biggest holiday displays.

There were plenty of other neighborhoods besides the zoo's immediate environs, of course, and some of those developed reputations as destinations to rival any tourist attraction. Throw out the question of where people traditionally went to see elaborate Christmas displays, and the one that is most immediately cited is a home at 5205 Clairmont Avenue, otherwise known as the "Santa Claus house."

In a 1967 article about the most decorated neighborhoods, the *Birmingham News* stated: "Few other residential areas can compare to Crestwood when it comes to beautifying lawns for the season. Santa Claus replicas entering chimneys, nativity scenes and sugar plum fairies are just a few of the mainstays of these glowing decorations that attract large crowds to the Crestwood side of Red Mountain."

It was that same year that Ed Levins, co-owner of some twenty McDonald's restaurants in Birmingham, first donned a leftover Santa suit and stood outside his Clairmont Avenue home, apparently an inanimate figure. When a carload of kids would pass, the "mechanical" Santa would come to life. "The kids would shriek with delight," he recalled.

For the next several years, Levins kept adding to his holiday display, installing regiments of illuminated toy soldiers on the lawn and wrapping the house's huge front columns with red ribbon to simulate giant candy canes. Levins, in his Santa suit, stood in the glare of a floodlight on a second-floor balcony, waving to an estimated 2,500 passersby nightly and yelling "ho, ho, ho" until his voice was no, no, no more. The tradition came to an unfortunate end in 1975, when Levins and his wife divorced. Levins moved to Gadsden

(where he kept up the tradition of extravagant Christmas decorations), and the rest of the family remained in the home on Clairmont, which was now dark during the holidays.

In 1982, Levins's fifteen-year-old son, Rusty, decided to revive the tradition for those who remembered it and even more so for those who had been too young to see it. A teenaged Santa Claus might have been a bit obvious if encountered at Eastwood Mall, but from a rooftop balcony at night, even Rusty's thirteen-year-old brother, Mark, and their elder sisters were able to rotate shifts doing the ho-ho bit. The "return of Santa," not to mention the toy soldiers and candy cane columns, made newspaper headlines, even if the crowds were no longer as large as in the early 1970s. And in 1986, for the first time since the Clairmont Santa concept was revived, Ed Levins stepped back into the suit during a Christmas week reunion with the rest of the family. When Levins died in July 2015, his Santa suit was among the family mementoes displayed at the funeral home.

Crestwood was not the only neighborhood where one could see Santas, living or otherwise. One hilltop home on U.S. 78 in Forestdale was known over three decades for its life-sized mechanical Santa on the front porch, turning and waving in the spotlight's glow. On Twentieth Avenue Northwest, near Jefferson State Junior College, Santa and his missus teamed up to greet holiday drivers. On Memory Lane in Crestline, a gentleman named Billy Hood took a page from the Levins family and waved at folks from a sleigh perched atop a rock outcropping.

All of this outdoor decorating seems to have really gotten started around the time the 1940s were becoming the 1950s. In 1949, the *Birmingham News* summarized:

> *This time tomorrow, a huge Star of Bethlehem will glow over Mountain Park Circle. Another will be lighted Sunday in Bush Circle. All over town, electric lights are beginning to shine as the little Christmastime deeds that give the Birmingham Christmas its traditional spark of good will and serenity.*
>
> *Lighting of the Mountain Park and Bush Hill Circles are community projects, in which the men do the work and the families share the cost. They perhaps are the city's most beautiful Yule decorations.*

Nothing was mentioned about the longest-surviving giant lighted star, the one topping the hill in Homewood. Perhaps inspired by the others mentioned above, the Homewood star was in place by 1955 and is still one of the most anticipated harbingers of the holiday season each year.

The giant lighted star first shone over Homewood in the early 1950s; it continues to make an annual appearance as one of the longest-lasting Christmas traditions of the suburbs.

By the following Christmas, outdoor decorating had become popular enough to inspire a lighting contest sponsored by the *Birmingham News*. Although fifteen years later such contests would be ridiculed as the height of crass commercialism in *A Charlie Brown Christmas*, people in 1950 were encouraged to jump into the competition with both feet. First and second prizes were to be awarded in each of seven defined areas: (1) Birmingham, east of Twentieth Street; (2) Birmingham, west of Twentieth Street; (3) Bessemer; (4) Fairfield; (5) Tarrant; (6) Irondale, Mountain Brook and Crestline Heights; and (7) Shades Mountain, Vestavia and Homewood. Decorations were to be separated into two categories: "Decorated and lighted yards or gardens, outdoor living trees or shrubbery" and "Displays on the house or visible through windows from the street."

Even in that relatively early period, some people's decorations made news by their sheer originality. The home of Leonard Cadle at 220 Overbrook Road in Mountain Brook featured illuminated figures of Santa, his sleigh and Rudolph the Red-Nosed Reindeer, whose hit song had been a smash for Gene Autry the previous season. (Outdoor Rudolph decorations took a

The banquet room at the Holiday Inn in Bessemer was decked for the Christmas party held by American Cast Iron Pipe Company (ACIPCO) in 1955. The motel had opened just one year earlier as the first Holiday Inn in Alabama. *Mike Cowart collection.*

flying leap in popularity after the debut of the animated TV special in 1964.) In 1953, residents of Lakewood Estates on U.S. 11 beyond Bessemer placed a lighted Christmas tree on a float in the lake from which the neighborhood took its name. Proving that some ideas never go out of style, thirty years later a similar tree (but fashioned from strings of lights) floated in a lake on the sprawling Hallmark estate on I-65 near Warrior.

Beginning in the early 1960s, residents of Montrose Circle decorated the Mountain Brook neighborhood with wooden cutouts of all the beloved Mother Goose nursery rhyme characters. The fairyland figures were still making annual appearances in 1983. At that same time, six hundred Hoover residents were lining a route from Patton Chapel Road to Sulphur Springs with fifteen thousand candles, encased in paper bags, weighted with sand and placed at six-foot intervals along the road.

The source for many of the prize-winning decorations was longtime downtown fixture Fix-Play Displays, which, as we have already seen, was primarily in the business of supplying cities and shopping centers with their huge street ornaments. But as home decorating got more popular, Fix-Play's showroom would open during October with the latest in outdoor decorations

143

The source for many Birmingham homes' and businesses' holiday decorations was Fix-Play Displays on First Avenue North. The store itself became something of an annual destination for those who just wanted to browse.

for homes and yards. Fix-Play became a Christmas destination of its own, with many people visiting just to look at its merchandise whether or not they intended to buy any of it.

But for all the pageantry and contests and shopping and parading, the whole season came down to that magical night: Christmas Eve. Somehow, the arrival of that mystical evening and the glorious morning that followed seemed to bring out the eloquence in newspaper writers (often anonymously)

each year. Just as those beautiful pieces of writing closed out the annual holiday season, so, too, are we going to let selected excerpts finish up this multipage examination of what Christmas meant in Birmingham.

The World War II years were tough for everyone, but perhaps no wartime Christmas seemed as bleak as 1943, when the war had been raging for more than two years and no one could see an end in sight. That Christmas Day, an unidentified *Birmingham News* writer penned these words:

In too many homes, loved ones were absent from the festivities, and while there was a brave show of happiness and gaiety, tears were choked back as memories of other, happier, peaceful Christmases filled anxious hearts.

Memories of the Christmas when Johnny got his first bicycle... Memories of the year when he and dad both got shotguns so they could hunt together...And then, the Christmas when, after a mother-father conference, it was decided he was old enough for his first tuxedo...

Memories of a young husband's and wife's first Christmas together... And then the first time they put toys under a tree together ...

Memories of sister's first "big doll" with eyes that would open and close...The Christmas morning when her thrilled squeals filled the house when she opened the package that held a tiny watch all her own...

On I-65 near Warrior, the vast Hallmark estate was always a showcase of Christmas lights, but this being Alabama, the snow was a rarer accessory.

Johnny...the young husband...sister...all absent today, celebrating Christmas as best they can all over the world, in training camps and on the battlefield.

Things were certainly more cheerful in 1949, and that is when writer Dan Cobb described Birmingham on that Christmas Eve:

Our town greeted the beginning of the holidays by wearing a cloak of happy anticipation. Everywhere there was something of Christmas:

In the few offices that opened today—just long enough to exchange Christmas wishes of the season. In the spicy aroma of a grandmother's kitchen. In the stores where late shoppers were getting their last minute items. In the voices of the sales persons who knew that soon they would be off. Most of the downtown stores closed at 5:30 p.m. so that employees too could get home early to be with their families.

Our town is happy.

Because it's Christmas Eve.

A column on the editorial page on December 24, 1969, had some of the same flavor:

Excitement and confusion and hectic activity—presents to unwrap, feasts to prepare, friends and relatives to greet—dominate the consciousness most of Christmas Day.

It is different on this night, the night before.

The pre-Christmas crush of things-to-do is over, and there are a few moments, a few hours, to be quietly cherished before the next day's bustle begins. During these quiet hours there is more time and more tendency to reflect on the beauty and the promise of the Biblical story.

It is indeed a "silent night," and the silence is pregnant with meaning for each man to read for himself.

It might have been the same writer who returned to the editorial page in 1971 to continue that thought:

If the time has passed when Christmas Eve meant excitement almost too great to hold; suppressed laughter and a fast, warm hug before they raced off to bed, then the memories are there to remind those who remain that the joys of childhood on Christmas Eve is a chapter in the story we shall never tire of returning to and reading over and over again.

Treasure the time, and especially hold the final hours before midnight close. You share them with others all too few times, and no other part of the passing years can touch them. There is a tenderness about the evening and a magic that time will not dim.

One of the *News*'s more renowned writers, Garland Reeves, made these comparisons in 1974:

Christmas is a time of excitement, movement, light and joy. It's reflected not only in the huge lighted star hanging over a street in Homewood, but in the flash and sparkle of evening traffic moving through the streets. It's reflected in the gentle grace and beauty of poinsettias at the Botanical Gardens, arranged for the annual Christmas show.

If Christ had not had the generosity to be born to mankind, man probably would have had to invent Christmas. He needs the brightness, the sparkle, the chance to look at the joys of life, the opportunity to smile. He needs the love.

In 1978, Palmerdale resident Clark Hogan made these deep observations a couple of weeks before Christmas:

Very likely few parents understand the seriousness of children's secret world of make-believe. That wonderful age of fantasy and dreams that we really never wish to leave, and chances are, we merely change make-believe into another word, "hope," as we are committed to the world of reality with all its indefinable tomorrows; some good, some bad, and for so many adults a wearisome journey from which they are glad to escape.

With so many years behind me and so few ahead, I realize that it was often the small things, and a child, that most affected my life. In memory, one of those is always near, and neither space nor time, nor future dimension, change me. I'll always remember a small voice saying, "Wait for me, wait for me." And I'll be waiting, I am sure, forever.

And finally we come to freelance Birmingham writer Sara Askew Orr. In a lengthy 1995 article recounting the glories of downtown at Christmastime and many of the other traditions we have covered in these pages, she ended with these observations:

Nostalgia plays tricks on our minds. I had such a happy childhood that everything that took place then seems wonderful and great now. I had no deep, dark secrets that were insurmountable. I know that many children did, though. And maybe for those people, the bright lights and colorful decorations at the malls now signify a happier time.

My child may never know the joys of Christmas downtown. But I hope she will have good memories from where she is now. I guess that's what we can all hope for: that each generation preserves some happy memories to share with their children and grandchildren.

Amen, Sara—and God bless us every one!

BIBLIOGRAPHY

BOOKS

Baggett, James L. *Historic Photos of Birmingham*. Nashville, TN: Turner Publishing, 2006.

Barton, Jessica L. *Historic Photos of Birmingham in the '50s, '60s and '70s*. Nashville, TN: Turner Publishing, 2010.

Bennett, James R. *Blach's: The Store, the Family, Their Story*. Memphis, TN: TVA Publishing Co., 2013.

Century Plus: A Bicentennial Portrait of Birmingham, Alabama. Birmingham, AL: Oxmoor Press, 1976.

Hollis, Tim. *Birmingham's Theater and Retail District*. Charleston, SC: Arcadia Publishing, 2005.

———. *Loveman's: Meet Me Under the Clock*. Charleston, SC: The History Press, 2012.

———. *Memories of Downtown Birmingham: Where All the Lights Were Bright*. Charleston, SC: The History Press, 2014.

———. *Pizitz: Your Store*. Charleston, SC: The History Press, 2010.

———. *Vintage Birmingham Signs*. Charleston, SC: Arcadia Publishing, 2007.

Keith, Todd. *Birmingham Then and Now*. San Diego, CA: Thunder Bay Press, 2008.

King, Pamela Sterne. *50 Years and Counting: A History of Operation New Birmingham*. Birmingham, AL: Operation New Birmingham, 2008.

Lewis, Pierce, and Marjorie Longenecker White. *Birmingham View: Through the Years in Photographs*. Birmingham, AL: Birmingham Historical Society, 1996.

McMillan, Malcolm C. *Yesterday's Birmingham*. Miami, FL: E.A. Seemann Publishing, 1975.

Smith, J. Morgan. *Bromberg's: An Alabama Tradition for 150 Years*. Birmingham, AL: Southern University Press, 1987.

White, Marjorie Longenecker. *Downtown Birmingham*. Birmingham, AL: Birmingham Historical Society, 1977.

Whitmire, Cecil, and Jeannie Hanks. *The Alabama Theatre: Showplace of the South.* Birmingham, AL: Birmingham Landmarks, Inc., 2002.

NEWSPAPER AND MAGAZINE ARTICLES

Alexander, Martha. "Magical Lights of Christmas to Shine." *Birmingham News,* November 23, 1956.

Azok, Dawn Kent. "New Shine on Old Favorite." *Birmingham News,* August 9, 2013.

Beiman, Irving. "Birmingham Ready to Celebrate Its Merriest Milestone in 75-Year Career." *Birmingham News,* November 24, 1946.

———. "Five Points West Shopping City to Be Enlarged." *Birmingham News,* March 1, 1967.

Bell, Elma. "Trees Festival Will Spotlight Holiday Delights." *Birmingham News,* November 26, 1984.

Birmingham News. "All Birmingham Ready to Open Up for Gay Carnival Season." November 18, 1941.

———. "Balloon Giants Thrill City." November 29, 1966.

———. "Big Balloons, Bands, Santa to Be Highlights of Parade." November 28, 1966.

———. "Birmingham Will Be Brilliant Fairyland." November 27, 1931.

———. "Boar's Head Festival to Be Next Sunday." December 10, 1961.

———. "Bright Colors and Originality to Be Added to Dazzling Fete." November 10, 1940.

———. "A Bright Night for Kids, Santa." November 30, 1968.

———. "Children Make Stable, Dress Up to Present Living Nativity Scene." December 22, 1977.

———. "Children of All Ages Enjoy Parade Magic." November 16, 1968.

———. "Christmas Fantasy, as Lived at Riverchase Galleria." November 9, 1986.

———. "Christmas Magic Begins Weaving Its Mystic Spell." December 13, 1942.

———. "Christmas Party for Kids Replacing Lighting Ceremony." November 23, 1975.

———. "Christmas Season Magic." November 24, 1978.

———. "Christmas Signs Displayed in July." July 21, 1973.

———. "Christmas Will Be Outdoors in Lights." December 16, 1953.

———. "Christmas—Yet Something Lacking." December 25, 1943.

———. "City's Yule Lights to Blaze." November 24, 1963.

———. "City to Don Festive Yule Glitter." November 20, 1953.

———. "City to Flip Switch…Presto, Yule Magic!" November 24, 1966.

———. "City to Welcome Santa Tonight." November 25, 1960.

———. "City Will Dress in Its Christmas Holiday Best." December 18, 1967.

———. "City Yule Decorations Hinge on Funds." October 18, 1954.

———. "Energy Shortage, 1973." December 22, 1973.

———. "Fairyland for Downtown." November 10, 1940.

———. "Fairyland Parade with 30 Balloon Animals Will Delight Kiddies Tonight." November 28, 1946.

———. "Festival Parade Set for November 16." November 1, 1968.

————. "Few Brave the Cold Downtown to See Merchants' Annual Christmas Parade." December 20, 1981.

————. "First Toy Parade Here on Saturday." December 18, 1964.

————. "Former Woman of the Year to Direct Yule Caroling." September 22, 1958.

————. "Give Someone Health for Christmas." November 16, 1951.

————. "Holiday Season Marches into Downtown Saturday." November 12, 1968.

————. "Huge New Shopping Center to Be Built Near Fairgrounds." April 1, 1941.

————. "If You Must Be in a Hospital Christmas, It Will Be Cheery." December 17, 1954.

————. "Just What Is a Mall? Webster Gives Answer." August 24, 1960.

————. "Kiddies, Who Love Parades Best, Will Make City Streets a Land of Music." November 22, 1949.

————. "Lighting Program Bathes City in Radiance." November 28, 1931.

————. "A Living Display of Color for Christmas." December 16, 1962.

————. "Nativity Scenes Tell Christ Story." December 16, 1961.

————. "News-Age-Herald Float to Carry Royalty." November 24, 1935.

————. "The Night Before." December 24, 1971.

————. "Nighttime Safari." December 31, 1993.

————. "No Red Flashes on Tree of Hope." November 18, 1964.

————. "A Parade to Cheer the Heart, Rest the Eye, Was 'Land of Music.'" November 24, 1949.

————. "Park Tree Used for Christmas Lighting Cut Down." December 8, 1985.

————. "Real Christmas Spirit Glows Warmly in City with Neighborly Love and Charity." December 16, 1949.

————. "A Real Pony for a Lucky Youngster." December 1, 1954.

————. "Santa Claus Taking Helicopter to the Mall." November 28, 1968.

————. "Silent Night." December 24, 1969.

————. "That Yule Spirit Is in Town." November 21, 1948.

————. "There's a Star Downtown." December 20, 1974.

————. "There's Sparkle Plenty All Around Our Town." December 23, 1953.

————. "Tree Lighting." November 22, 1979.

————. "Tree Lighting Event Reset for Monday." November 26, 1967.

————. "Tree Reflects Spirit of Christmas Seals." December 22, 1965.

————. "Watch for 'Stars of Hope.'" November 16, 1964.

————. "Yule Therapy Brings Cheer to Children." December 16, 1948.

————. "Yuletide Lights to Decorate Town After All." September 23, 1958.

Birmingham Post-Herald. "Christmas Parade Set for Downtown." December 4, 1982.

————. "Fourth Avenue Merchants Set Christmas Parade." December 5, 1981.

————. "Live Nativity Scenes Will Highlight Holiday Season." December 19, 1981.

————. "Merry Christmas More Than Greeting." December 1, 1980.

————. "Nativity Scene Given for Park." November 17, 1965.

————. "Thousands of Youngsters Awed by Giant Balloons." November 29, 1966.

Braswell, Fred. "A Lonely Walk Through Century Plaza." *Birmingham News,* September 13, 2008.

Brown, Don. "City Under One Roof Opens Tomorrow." *Birmingham News*, August 24, 1960.

Bryant, Joseph. "Copper Thieves Burn Down City of Birmingham's Christmas Tree." *Birmingham News*, December 15, 2010.

Bryant, Walter. "Christmas Spirit Captured in Church Drama, Pageantry." *Birmingham News*, December 13, 1975.

———. "Church Filled with Yule Trees from Around World." *Birmingham News*, December 13, 1975.

———. "Wilson Park's Christmas Tree Endangered." *Birmingham News*, February 8, 1985.

Caldwell, Carla. "Christmas at the Zoo Offers Break from Revelry." *Birmingham News*, December 26, 1990.

———. "Yule Glow All in Family." *Birmingham News*, November 23, 1987.

Campbell, Joe. "Peace on Earth Parade Theme." *Birmingham News*, November 24, 1955.

———. "Santa to Lead Ensley Parade." *Birmingham News*, December 1, 1955.

———. "Sprawling Five Points West Business Complex Evidences Faith in Future." *Birmingham News*, October 16, 1963.

Carter, Lane. "Local Churches to Present Pageants and Plays with Christmas Theme." *Birmingham News*, December 17, 1944.

Cobb, Dan. "Visions of Sugar Plums Dance in His Head." *Birmingham News*, December 24, 1949.

Crowson, Bryan. "Carraway Blue Star Shines on from '50s." *Birmingham News*, December 20, 1991.

Frieden, Kitty. "Missing Yule Lights Draw Fire from Council." *Birmingham News*, December 16, 1982.

Fullman, Lynn Grisard. "Friends Unveil Plans for Park." *Magic City News*, June 1984.

———. "Turning on Christmas Magic Becomes Neighborhood Affair." *Birmingham News*, December 18, 1983.

Gibson, Tom. "Dixie Christmas at Arlington." *Birmingham News*, undated clipping circa 1964.

Goodman, Sherri C. "End of a Retail Icon." *Birmingham News*, May 14, 2006.

Harvey, Ann. "By Popular Demand, Santa Has Come Back to a Rooftop in Town." *Birmingham News*, December 21, 1982.

Hogan, Clark. "The Many Moods of Christmas." *Birmingham News*, December 16, 1978.

Howell, Vicki. "Zoo Previews Holiday Light Show." *Birmingham News*, September 29, 1993.

Jones, Melanie. "Family Carries on Tradition of Neighborhood Santa Claus." *Birmingham News*, December 24, 1986.

Joynt, Steve. "Park Aglow with Christmas Lights." *Birmingham Post-Herald*, December 1, 1993.

Kennedy, Joey. "Mutt-Cracker." *Birmingham News*, December 12, 2014.

Kent, Dawn. "Mall Closes after Four Decades." *Birmingham News*, June 2, 2009.

Kindred, Ingrid. "Bromberg's, Others Relight Downtown Christmas Sparkle." *Birmingham News*, November 28, 1992.

Koenig, Bill. "Retailers Just Can't Wait for Christmas." *Birmingham Post-Herald*, November 18, 1982.

Marzoni, Pettersen. "City to Be in Joyous Spirit as King Cheer Rules Supreme." *Birmingham News*, November 26, 1935.

McGuire, Pat. "Arlington to Celebrate a Nostalgic Christmas." *Birmingham News*, November 24, 1974.

Merrill, Hugh. "Huge Crowd Turns Out to See Parade." *Birmingham News*, November 29, 1966.

Milner, Laura. "Christmas Magic Casts Its Spell on People as Holiday Approaches." *Birmingham News*, December 23, 1980.

Morrison, Ellen Rossler. "Even Dave's Kids Didn't Know Santa Was Really Dad." *Birmingham News*, December 10, 1984.

Niolet, Benjamin. "City Leaders, Merchants Agree: Decorations Not a Pretty Picture." *Birmingham News*, undated clipping, 1996.

Orr, Sara Askew. "Today's Children Denied Joys of Christmastime Downtown." *Birmingham News*, December 18, 1995.

Reeves, Garland. "Lights Are Dim, Glitter Is Gone, but Christmas Is, Will Be Special." *Birmingham News*, December 24, 1973.

———. "The Spirit of Christmas—It Works, It Moves, It Glows." *Birmingham News*, December 22, 1974.

Roe, Kathy. "Skyscraper Lights Again in Spirit of Christmas." *Birmingham News*, December 15, 1983.

Sanders, Carl. "Sharp-Toothed Squirrels Make Impression on Holiday Lights." *Birmingham News*, October 20, 1978.

Shades Valley Sun. "Santa and Uncle Cliff to Help Open Jack's Hamburger Drive-In." November 23, 1960.

Shatz, Howard. "Wilson Park Renamed for City Benefactor, Pioneer Charles Linn." *Birmingham News*, December 24, 1986.

Sikora, Frank. "City to Become Fairyland for Balloon Parade." *Birmingham News*, November 21, 1967.

Simon, Susan. "Linn Park, a Green, Gentle Place, Is Revived in the Heart of the City." *Birmingham Magazine*, September 1989.

Smith, Anita. "Santa's Station Wonderful Way to Find Christmas Spirit." *Birmingham News*, December 6, 1974.

———. "10-Room Santa's Station Opens at Noon Saturday." *Birmingham News*, November 22, 1973.

Stallworth, Clarke. "The Spirit of Christmas Stays with One Jolly Man." *Birmingham News*, December 25, 1981.

Teague, Sarah. "City Houses Aglow with Decorations." *Birmingham Post-Herald*, December 22, 1982.

Walker, Alyce Billings. "Parents Back Proposal for 'One Santa Claus.'" *Birmingham News*, December 16, 1947.

Washburn, Dennis. "Hospitality Center Refuge for Gift-Weary Dropouts." *Birmingham News*, December 17, 1968.

Weaver, Emmett. "Two Months' Work and 300 Persons Go into Living Nativity Production." *Birmingham News*, December 15, 1956.

INTERVIEWS AND CORRESPONDENCE:

Carol Aldy, Harold Apolinsky, Benny Bliss, Harry Bressler, Michael Brewer, Jess Bullock, Mel Campbell, Fox DeFuniak, Pat Dietlein, Connie Haydock, Janice Johns, Rusty Levins, Lee Lyle, Jean Spradlin Miller, Patty Pendleton, Steve Pennington, David Ramp, Carolyn Ritchey, Winston Schepps, Jayne Schrimsher, Bill Smith, Jim Spahn, Temple Tutwiler III, Teresa Belrose Watson and Keith Williams

INDEX

T

Tutwiler, Temple, III 51, 52

V

Vaughn, Ralph 90
Veazey, Bill 90

W

Waldron, Gene 50
Walker, Evelyn 109
Walsh, M.E. 35
WAPI-TV 20, 105, 117
WBHK 55
WBMG-TV 81, 86, 114
WBRC-TV 38, 63, 90, 103, 110, 112
Weil, Ferd 39, 43, 65
Western Hills Mall 84, 85, 86, 88, 116
West Lake Mall 84
Williams, Keith 103, 105
WKBC 102, 103
WMJJ 99, 101
Woodlawn Methodist 123
Woodrow Wilson Park 35, 36, 40, 41,
 42, 43, 48, 50, 51, 52, 69, 128
Woolworth's 73, 85
WQEZ 97, 98
WSGN 102, 109

Y

Yeilding's 20, 104, 105

ABOUT THE AUTHOR

Tim Hollis has been a pop culture historian all his life. He likes to tell how, when he was nine years old, he was writing letters to companies trying to preserve the memories of things from when he was three years old. This mania for living in the past has resulted in twenty-six books (as of right now, anyway), ranging in subjects from southern tourism nostalgia and Birmingham history to children's television and children's records, among other topics. He also owns a museum of toys, advertising, holiday memorabilia and other baby-boomer relics that he makes available to visitors and researchers by appointment. Having lived in Birmingham his entire life, he supplies the nostalgic materials for the popular www.BirminghamRewound.com website, through which he may also be contacted.

Visit us at
www.historypress.net

···

This title is also available as an e-book